THE ART OF CARTOONING

Jack Markow

A combined publication of
Drawing and Selling Cartoons and *Drawing Comic Strips*

A Perigee Book

Perigee Books
are published by
The Putnam Publishing Group
200 Madison Avenue
New York, NY 10016

Library of Congress Cataloging-in-Publication Data

Markow, Jack, date.
 [Drawing and selling cartoons]
 The art of cartooning : a combined publication of Drawing and
selling cartoons and Drawing comic strips / Jack Markow.
 p. cm.
 ISBN 0-399-51626-3
 1. Cartooning—Technique. 2. Comic books, strips, etc.—
Technique. 3. Caricatures and cartoons—Marketing. I. Markow,
Jack, date. Drawing comic strips. 1990. II. Title.
NC1320.M268 1990 90-7054 CIP
741.5—dc20

Designed by Anita Karl
Printed in the United States of America
1 2 3 4 5 6 7 8 9 10

EDITOR'S NOTE

The Art of Cartooning is a delightful combination of two age-old
classics by master cartoonist Jack Markow. Those who love to draw
or simply enjoy the classic cartoons will treasure this volume and
appreciate that every effort has been made to reprint Mr. Markow's
books in their original form. Both the text and the drawings appear
here almost exactly as they appeared in their first editions, published
as early as the 1950s, when the art of cartooning was still relatively
young and wide open to technical innovation and wit.

CONTENTS

Creating a Cartoon Style

A cartoon is a stenographic approach to drawing. Getting your idea across *quickly, surely,* and *with humor* is most important. In most cases a too naturalistic portrayal of features, clothes, and background slows down the action of the cartoon. Therefore, we have to create symbols for the whole figure and its various parts.

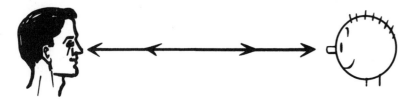

Somewhere between the two extremes shown above lies your particular style of cartoon.

Instead of using a naturalistic head outline, start with a simple abstract shape, such as an oval.

Consider this oval as a piece of wire which may be pulled and stretched into various shapes. As an experiment, take a piece of thin wire, and shape it into a silhouette of a head. Then mold it in various directions. The effects gained will give you a sense of the liberty you have to create outlines and forms.

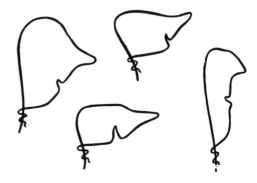

A cartoon style, whether tending towards the abstract (below) or the more realistic (next page), must be based on simple forms.

"You know the rules of the State Wrestling Commission, now get out there and act!"

4

"I've lost track, Tim. How many stories we got to go yet?"

The Features

Take a basic head shape, space certain features within this outline, and you have created a character. Let us start from the top of the head and work down, using our shorthand method.

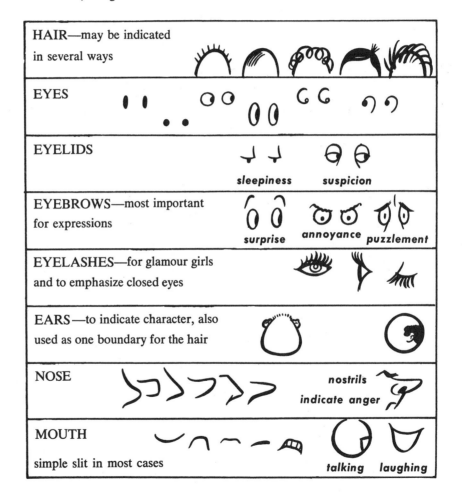

HAIR—may be indicated in several ways	
EYES	
EYELIDS	*sleepiness* *suspicion*
EYEBROWS—most important for expressions	*surprise* *annoyance* *puzzlement*
EYELASHES—for glamour girls and to emphasize closed eyes	
EARS—to indicate character, also used as one boundary for the hair	
NOSE	*nostrils indicate anger*
MOUTH simple slit in most cases	*talking* *laughing*

5

Constructing a Complete Head

The drawing of a head outline and a set of features spaced within this shape builds the complete cartoon head. In this example, the portly business tycoon is used as the guinea pig. All drawings should have depth.

Using the abstract shapes below, add a shadow to the side of the head to indicate depth. Place simple features within each face. Remember, the shape of the head and the spacing of the features within this area will create your type.

A. Triangle suggests our character.

B. Triangle becomes pyramid when shadow is added, creating three-dimensional form.

C. Pyramid with edges slightly rounded. Dotted line shows center of face, a guide to the placing of features.

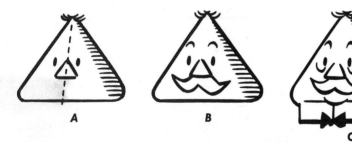

A. Addition of nose (a smaller pyramid), eyes, and hair.

B. Eyebrows and moustache added.

C. Complete with bags under eyes, ear, double chin, collar, and tie.

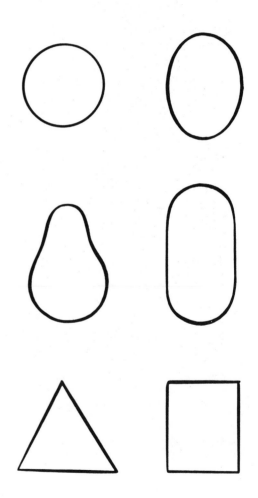

For example, taking the same triangular shape used for the businessman, adding different hair, spacing the eyes closer together and higher in the head, and using a different type of mouth, one which is pushed closer to the other features, we get a large-jawed, tough-guy type.

By inverting the triangle shape and spacing the features lower down, we get more brain room and less jaw space, thereby creating a scholarly type.

SIDE VIEW

Now that we have an idea of the head in three-quarter, let us acquaint ourselves with the head in other positions. The profile or side view is used most frequently in cartoons because of its simplicity (only one eye, one ear, etc., need be indicated). The construction is similar to that of the front or three-quarter view.

For the sake of variety, let us use the pear shape with a slight change of features to get the same tycoon type.

A **B** **C**

(A) Simple shape with shadow added for depth. (B) Features added. Note closeness of eye to the outline. Moustache extends slightly outside head outline to indicate its thickness. (C) Outline pushed back allowing more brain room.

BACK VIEW

Here, since we do not have too many features to work with, we make the most of the ears and hair.

THREE-QUARTER BACK VIEW

Note eye and moustache outside the outline, ear moved toward front of the face, and hair mass following the rounded form of the head.

In a composition of two figures this view balances a front or three-quarter front view.

Pantomime Cartoon

In a pantomime panel cartoon, which has no caption, the idea is put across primarily by expression and action. Since a multi-panel cartoon usually occupies the same small space in a magazine as a single-panel job, the figures are reproduced quite small. Therefore, as in the example, it sometimes becomes necessary to exaggerate and simplify the features

so that the facial expression may be readily seen. In this cartoon the ears were eliminated entirely since they did not especially add to the character or expression of the hunter.

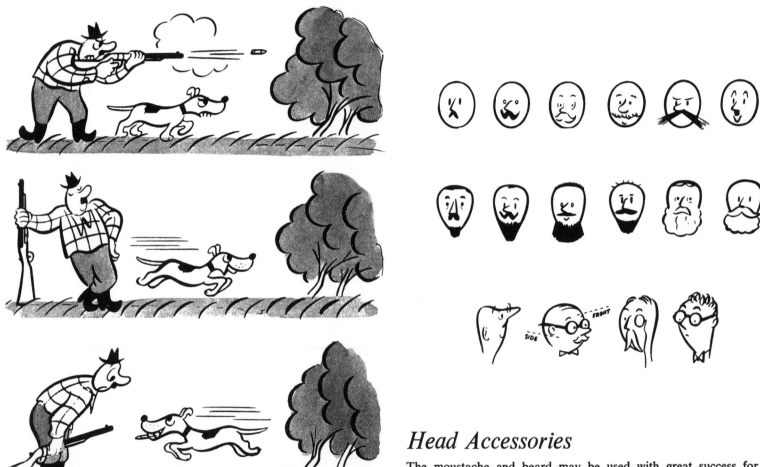

THE SATURDAY EVENING POST

Note the oval-shaped head of the hunter in this picture.

Head Accessories

The moustache and beard may be used with great success for male members of the cast to add variety of character. The moustache may take the place of the mouth entirely, and with it you can indicate many of the same expressions. Eyeglasses may also be used with telling effect to create character and to accent the form of the head.

THE HAT

The hat follows the form of the head whether it is worn properly, tilted, perched on top of the head, or pushed down over the ears. The hat is "meat" for the cartoonist. He has a device here which he can exploit to the fullest to add humor and character to his figures.

A. Front view. Hat angled toward back of head.
B. Three-quarter view. Hat tilted forward.
C. Brim drawn in form of figure 8.

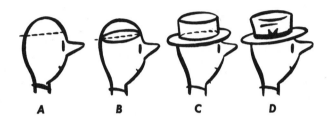

A. Angle of hat indicated by broken line.
B. Oval showing how hat goes around head.
C. Basic shape of crown indicated.
D. Varied crown with dents added.

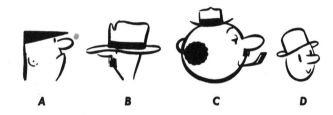

A. The cap based on triangular shape.
B. Big hat—small head.
C. Big head—tiny hat.
D. The derby.

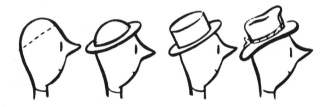

Completion of beaten-up hat derived from basic forms.

COLLAR AND TIE

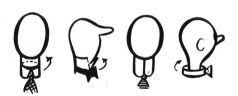

Constructing a Complete Figure

Taking the first head which we constructed, let us build up a figure, complete with arms and legs. Just as you started with a simple shape for the head, indicate a simple form for the body. You again have the choice of an oval, pear shape, square, rectangle, triangle or any other simple shape. You have a triangular head. What body shape will go best with it: triangle, oval, square, rectangle? In this case an oval or pear shape will be the best basis for the body.

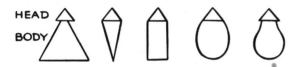

In drawing, *contrast* is most important whether it is contrasting shapes, contrasting lines, or contrasting tones. This helps make a picture interesting to the eye and mind. Therefore—angular head, round body. Also, for the type we are portraying here, the oval is best as a motif for a substantial figure to go with a substantial type.

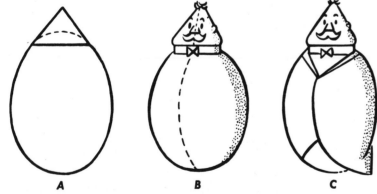

A. Head superimposed on oval.

B. Simple shadow to denote form. Dotted line indicates center of body, a guide to drawing clothes.

C. Triangles for lapels. Cutaway coat indicated.

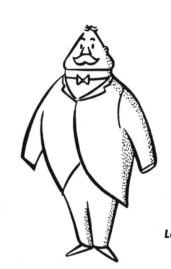

Arms get slightly narrower from shoulder to wrist.

Legs narrow down from waist to ankles.

Get a feeling in your drawing of the lapel going all the way around the head. At this stage, use tubular forms to indicate arms and legs.

SIDE VIEW

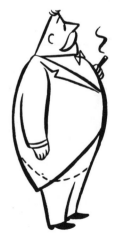

Even if the figure is in full profile, it is wise to indicate what is happening on the side of the body we cannot see.

10

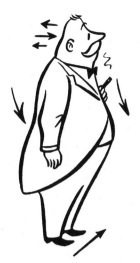

Force an indication of the other arm by showing the left hand and cigar. The left leg adds both dimension and stability to the figure.

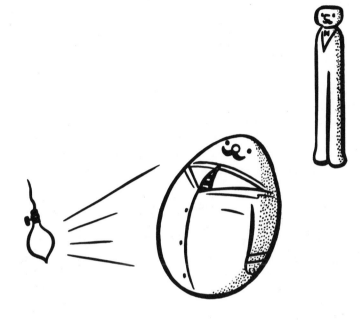

BACK VIEW

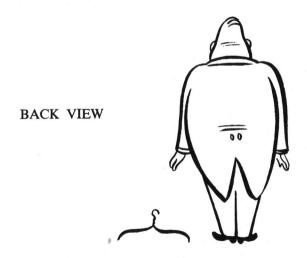

Note coat hanger bulge to express shoulders.

Keep your figures compact, well-knit, and as simple in silhouette as possible. Try this: Raid your icebox and get a hard-boiled egg. When the egg is lighted from one side, observe form and the simplicity of contour. For contrasting shape do the same with a clothespin. Consider the simplicity of these two forms as the basis of cartoon drawing. Draw the head, clothes, and features on the egg and clothespin.

Up to now we have worked with the *static* figure. In a later chapter we will study the figure in action. But first, practice with the static figure, using various body and head shapes in different combinations, rounding out certain parts, and choosing those features you wish to emphasize. The more you practice along these lines, the faster you will develop your own particular cartoon style.

Hands

Aside from functioning as a normal part of the human body, hands can be one of the most expressive features in a cartoon. Like everything else in the cartoon, they must be brought down into simple forms. For purposes of modeling at a moment's notice, there are, of course, no hands more readily available than your own.

For simplification, the hand should be thought of as a mitten—the thumb as one unit, and the other four fingers as another whole unit.

The wrist should be shown whenever possible. The hand flexing around the wrist will give added action and expression. Remember that when a cartoon is reproduced, the hands show up very small. For this reason, *clarity* is essential.

Feet

Feet are primarily used as a base for the body. While feet in a cartoon should not be obtrusive, they can add to the over-all humor of a picture by being flexible. A supple foot will turn at the ankle and the toes. Exaggerate feet more toward smallness than largeness. For example, a mammoth individual with small, mincing feet can be very funny.

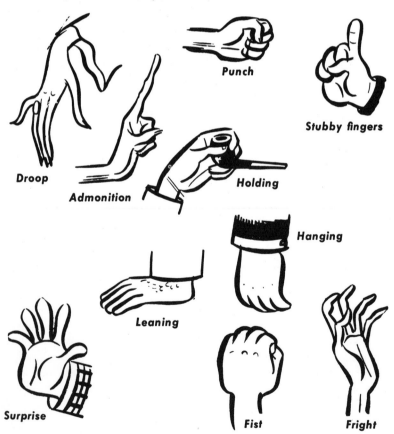

Droop

Punch

Stubby fingers

Admonition

Holding

Hanging

Leaning

Surprise

Fist

Fright

An indication of how fluid and supple feet aid in the humor and expression of a cartoon.

Female feet

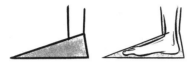

The bare foot and shoe, side view, may be abstracted down to a triangle.

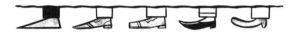

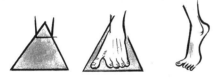

Again, consider the big toe as one unit, the four smaller toes as another unit.

Three-quarter view

Drawing Cartoon Types

These are some of the leading characters you may have to call upon to help in your production. Your invention may take you from a prison cell to a flying carpet. The cartoonist plays around with an infinite variety of subjects, and he must be ready and able to provide the right character for any setting. There are a tremendous number of types and characters

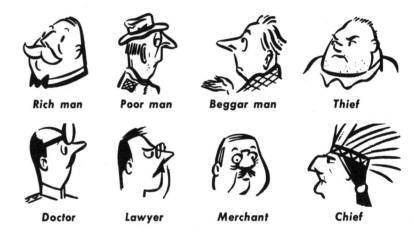

Rich man **Poor man** **Beggar man** **Thief**

Doctor **Lawyer** **Merchant** **Chief**

around you ready to be observed, sketched, and filed for future use in your cartoons. However, because the cartoonist covers such a wide field of subjects, there are many types which he would not bump into every day. To name just a few: sultans, harem gals, Foreign Legionnaires, Eskimos, hermits, penguins, Bali beauties, matadors, disk jockeys, lighthouse keepers, and movie directors. Therefore, besides observation and study of the types seen every day, the wise cartoonist studies types which he can only get to know through photographs, movies, television, etc.

Knowing how to draw man in various ages will help you in getting types. Six ages of man will be enough for the cartoonist's purpose—infancy, childhood, youth, manhood, middle age, and old age.

Taking the two extremes, infancy and old age, let us see what characteristics we find in the head profiles.

Both profiles of the baby and the old man may be fitted into a question mark. Both their necks are thin, and both may be bald, but there the resemblance ends.

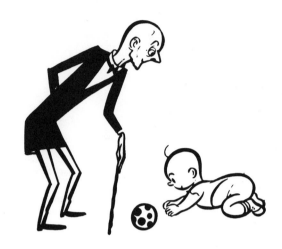

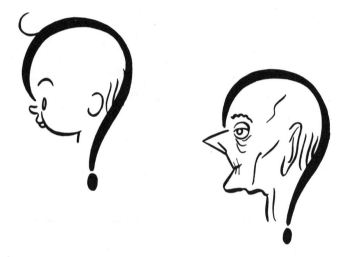

The infant's characteristics include the following: eyes below the center line of the head, large forehead, small features, fat cheeks, pouting mouth, everything rounded and full. The old gent's characteristics: smaller forehead, angular lines, face bony and shrunken, hanging folds of skin, scraggly neck. Both the baby's body and the old man's may be bent, but the baby's figure is composed of rounded lines throughout, and his head is quite large for his body. The old man's figure is thin, angular, with thin, bony hands.

Head Shapes

The following basic outlines may be used as head shapes for the six age groups:

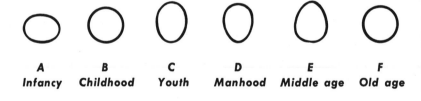

A	B	C	D	E	F
Infancy	*Childhood*	*Youth*	*Manhood*	*Middle age*	*Old age*

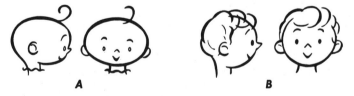

Eyes at head center and wide apart; small features usually; thin neck. Right: Eyes below head center and wide apart.

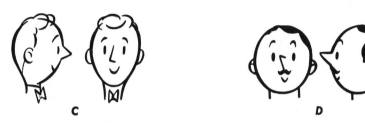

C **D**

Egg-shaped head narrowing towards chin; plenty of hair; eyes slightly above center. Right: Thinning hair; moustache; heavier neck.

E **F**

Very thin hair; heaviness at base of head; bags under eyes; double chin. Right: Angular; gaunt; sunken features; thin neck.

Girls

The keynote for gals, young or old, is *curves*. For cute girls, curve forehead in. Indicate eyelashes, cute upturned nose, full lips, small mouth, eyes slightly below center of head. In the profile leave sufficient space between the tip of chin and neck. The neck is long, not too thick, and column-like. Oval shapes and curves are also used for the older, more matronly type.

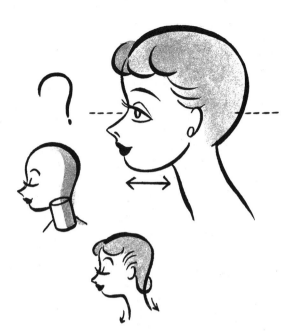

Features are usually smaller than men's.

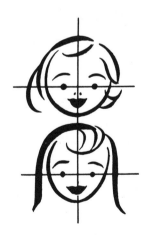

Heads, front view, are round or heart-shaped, eyes wide apart.

Draw cute girls between 7 and 8 heads high.

There are no set hair-do's or clothes, since styles keep constantly changing.

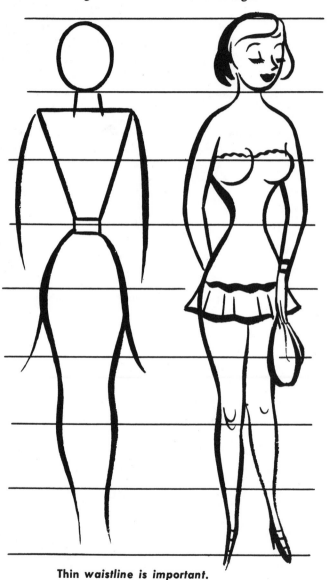

Thin *waistline is important.*

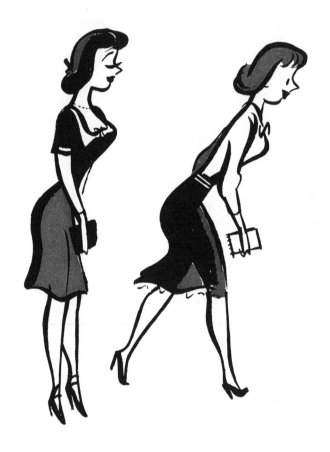

For the latest fashion, study the gals around you.

Doodling with pen and brush is excellent practice for developing style and technique.

Animals

Animals are a wonderful addition to your cast of characters. In cartooning animals, observe and emphasize the grace of certain animals, such as the horse, and the heaviness and clumsiness of other animals, such as the elephant. Exaggerated expression conveyed by the eyes and mouth add the comic touch.

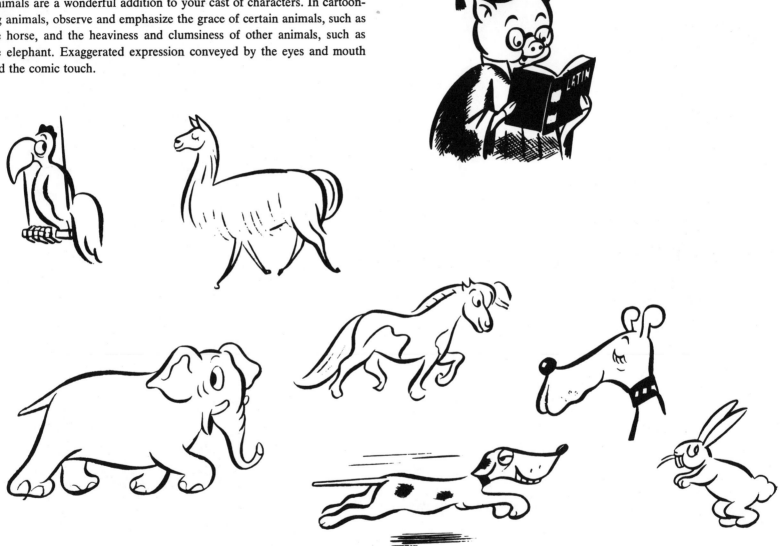

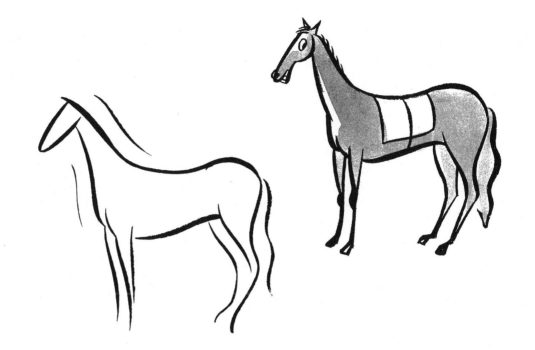

Rounded shapes make the pig, flowing lines the horse, angular shapes the cow.

Emotion

You have chosen your characters. Now it is time for them to act out your plot, your cartoon idea. Facial expression, combined with body gesture, is the most important factor in getting your point across with the utmost humor. The humor of the cartoon depends a great deal on the character and expression of the *head*. Faces in cartoons should not be hidden. The greatest impact on the audience will be achieved when the face of the character doing the talking, and the reaction of his remark on the faces of the other players in your cartoon comedy, can be readily seen.

In the following four heads notice how the expression is carried entirely by the movement of the eyebrow and mouth.

A. Eyebrow and mouth going in opposite directions create a pleased expression.

B. Sardonic look created by eyebrow and mouth both turned up (going in same direction).

C. Eyebrow and mouth turned away from each other convey displeasure.

D. Eyebrow and mouth both in downward direction produce hurt or sad look.

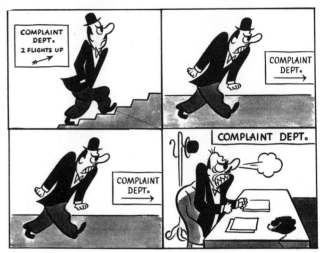

THE AMERICAN LEGION MAGAZINE

Below we show a progression of expression from the faintly amused to the pleased, the quiet laugh, and the guffaw. The movement of the head pivoting at the neck helps build up extreme expression *D*. Also note closed eye in head *D,* to enhance effect.

Let us do these in a three-quarter view:

Action of the hair, addition of nostril, and motion lines (head D) also help show extremes of emotion.

Let us now look at varying degrees of anger:

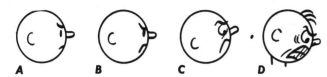

A B C D

In character D we really ham it up, throwing in everything to produce the extreme effect; wrinkles, bags, teeth, nostrils, baleful glare, and a threatening head gesture towards the victim.

Three-quarter view of the Angry One:

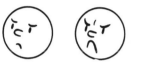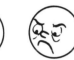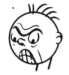

Facial expression and body gesture enhance each other.

Three laughing cartoons, showing how action is a factor in extreme expression. Note the slapping hand effect.

Sad character in four stages of emotion:

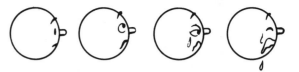

The movement and size of eye are added devices in conveying expression.

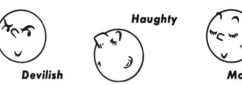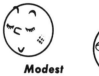 **Haughty** 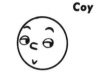 **Coy**

Devilish **Modest**

The Frightened One:

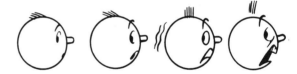

In these expressions of melancholy the body tends to sag downward. The hands also help in conveying emotion—the clenched fist and the drooping fingers.

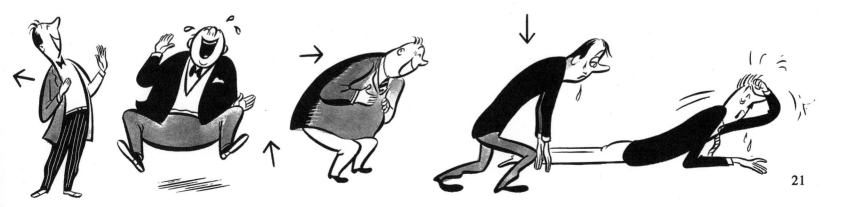

21

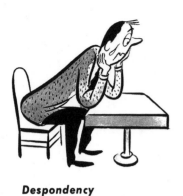

Despondency

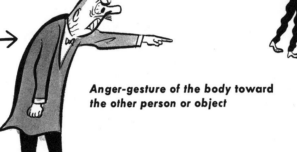

Anger-gesture of the body toward the other person or object

Fright-gesture of the body away from the other person or object

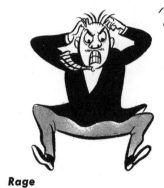

Rage

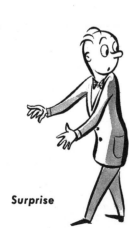

Surprise

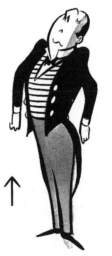

Haughtiness-gesture of body upward

Modesty

Shock

Here are some more impressions of expressions. Try your own versions of these and others, such as fury, melancholy, surprise, elation, enjoyment, coyness, glee.

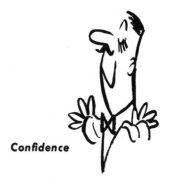

Confidence

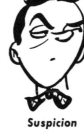

Remorse

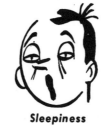

Suspicion

Sleepiness

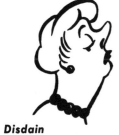

Disdain

Poker face

Aggression

Anticipation

Exuberance

Worry

Nobility

Action and Composition

Pose yourself in front of your mirror. Notice how the various parts of your face and body move. A cartoon figure can illustrate all these actions, and more. For, unlike an illustrator, the cartoonist may take extreme liberties in giving life to his cartoon figure—the heads may be twisted entirely around, and the eyes may be popping.

Some cartoon ideas require violent action and some require "quiet" action. Examples of the latter include standing, sitting, talking, the type of action or gesture that is used for quiet, conversational gags.

It is much more difficult to portray a quiet-action cartoon than it is to evolve a violent-action picture of two or three people fighting. The latter is a natural in evoking a reader's interest because of its subject matter and the greater opportunity to exaggerate action lines. In tackling a subject of two people talking, the artist must deal with the action more subtly, since action does not especially aid in putting this type of cartoon idea across.

Most beginning students make a common error when composing two figures together; their first efforts have a sameness of posture, and the result is monotony.

This is a little better. By curving one of the figures we get a more interesting picture. Already, tension is beginning to develop between the two main elements of the picture. But this is not enough. Drawing both figures in profile still makes for monotony.

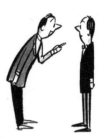
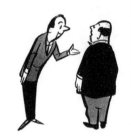

A three-quarter front view and a three-quarter back view add still more interest. One thin figure and one heavier figure create more variety of character.

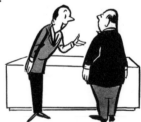

A table or desk connecting the figures helps solidify the composition.

Another improvement would be to have one figure standing and one seated.

Why do we try to avoid straight up and down lines as the basis for our figures? Why do we prefer lines such as these?

One good reason is that backgrounds, props, furniture, wall panels, doors, and windows must be drawn, in most cases, with horizontal or vertical lines. Therefore, whenever possible, you are *obliged* to use a different type of line as the basis for your figures in order to relieve the monotony of these horizontal or vertical prop and background lines. Also, curved, diagonal, or dynamic lines used as a basis for your figures will, by their contrast with the more monotonous background lines, draw the reader's attention to the figures. This is as it should be, since people are the most important element in any cartoon.

Remember, these are static lines. **These are active, dynamic lines.**

Observe the direction and contrast of line in the following illustrations.

Hooked line of the figure contrasting with straight lines of structures.

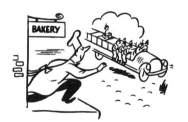

Streamlined action line gives speed to the baker and contrasts with straight lines of the building and the engine.

Violent Action

Observe the running gentleman below. All the devices to provide speed are used and the entire figure is based on a streamline. The hair, necktie, coattails, glasses, and hat fly back, accentuating the pushing, forward motion of the figure. Speed lines are used and the figure gains more action by being lifted off the ground.

What is your version of a running figure? In cartooning there are no set action poses. You have complete liberty to twist, stretch, and turn your figures to get proper action and to make your brainchildren silly and funny looking. In drawing an active character, begin with a simple stick figure emphasizing the big line of action. By doing this you completely concentrate on the action first. Later, you may build up the figure however you wish—fat, thin, old, young, etc.

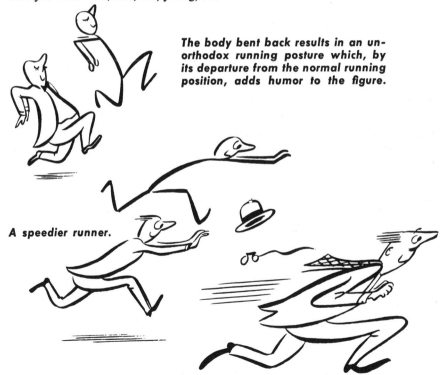

The body bent back results in an unorthodox running posture which, by its departure from the normal running position, adds humor to the figure.

A speedier runner.

More extreme action line, resulting in the speediest runner of all.

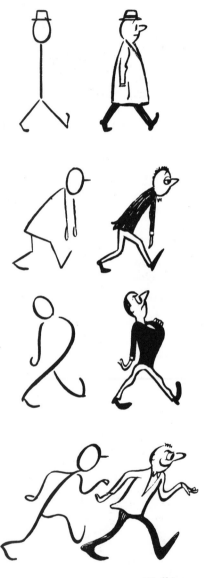

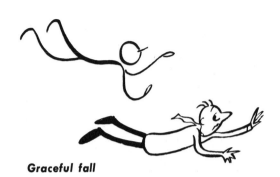

Graceful fall

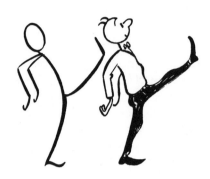

Kicking

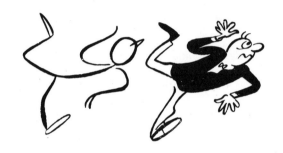

Awkward fall

Back kick

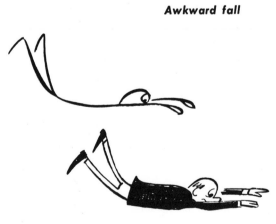

Three-point landing

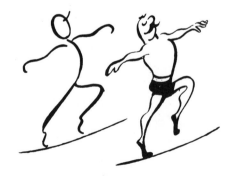

Balancing

Walking

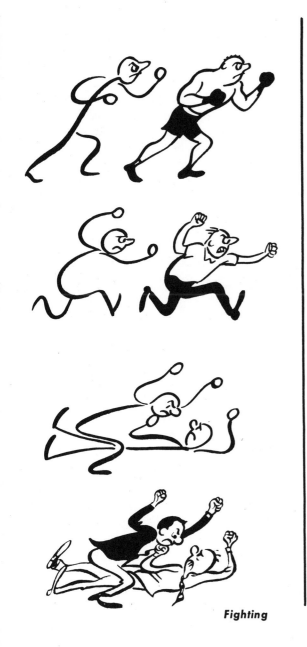

Fighting

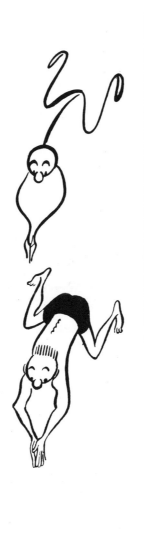

Diving

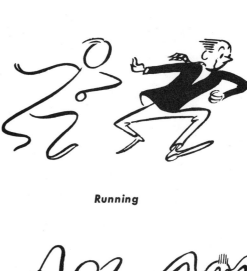

Running

Jumping

Walking

Drawing Backgrounds

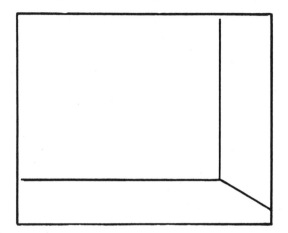

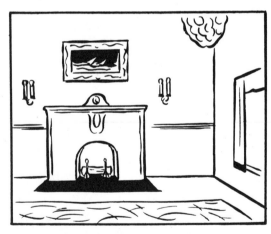

Every object, no matter how complex, can be broken down into basic, simple forms. Once you have done that, you can begin to add detail. Thus, a living room can be seen as the inside of a cube. Add windows,

a door, lamps, drapes, etc., and you have the start of a picture pleasing to the eye.

Draw your own room for practice. First, put down the bare skeleton of the room, or corner of the room. Then embroider it with windows, doors, pictures, and lighting fixtures. Windows and door are much used props in cartoons. Indicate thickness in these, as in all other props. Practice drawing doors open, shut, and partly open.

Interiors

Draw these props carefully at first, *even using a ruler,* until you get to the point where you can draw them casually and simply, retaining the big aspects of the prop without obtruding upon the more important living characters in the picture.

Observe interiors wherever you go. They may come in handy in future cartoons you draw. Also, observe interiors in movies and television productions as well as those in magazine photographs, for a cartoonist is called upon to draw many unfamiliar interiors, ranging from the interior of a harem to that of a prison cell. Knowledge of chandeliers and where to put them is important in pinning down the character of a room, as well as adding height to a picture.

Block form

Curtains and drapes require study and simplification of folds. Rugs are important for the design quality and texture that they add to a picture. Similarly, practice on radiators, venetian blinds, or anything that dresses up the walls, ceiling, and floor of a room.

Block form

Block form

Getting away from the walls and into the room, we have the problem of furniture. Again, valuable research may be done directly in your own rooms and in pictures in mail-order catalogs and furniture ads. As you introduce furniture into your picture, start again with a simple, solid shape. Then add details and ornamentation.

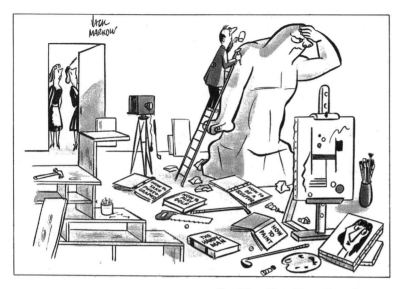

THE NEW YORK TIMES BOOK REVIEW

"Maybe I shouldn't have given him all those 'How to' books."

Creating Cartoon Ideas

With patience and hard work, almost anyone can develop the ability to originate humor for cartoon panels. Good salable gags do not come easily even to the most accomplished idea men. Nowadays, the regular weekly routine of the cartoonist is, first, the invention of from 10 to 20 fresh humorous situations, and then the presentation of these ideas in sketch form to the various cartoon editors. Some good funny lines are garnered from chance conversation, or remarks overheard, but the number of these is only a small percentage of a cartoonist's annual total of cartoon roughs. An idea may begin with either the caption or the picture. Inspiration comes mostly in the quiet seclusion of the cartoonist's work room. Here, toiling alone and using visual and other aids as stimuli, he can cover a wide range of subjects.

The gag idea is all-important in selling a cartoon. While editors will buy a comic with a funny idea but with only adequate drawing, the finest drawing coupled with a poor gag will never sell. For the complete effectiveness of a cartoon, the idea and the drawing should be equally excellent. Many a funny gag, however, has been completely slaughtered by the novice who did not know how to put his idea across. Fortunate is the cartoonist who can both draw well and originate fine gags.

Categories of cartoonists at work today include: 1. those who create all their own ideas; 2. those who create some of the gags and buy some from professional gagmen; 3. those who purchase *all* ideas from gagmen. There are some cartoonists who have no flair at all for dreaming up funny ideas. These cartoonists need not despair. They should concentrate on their drawing, building up a humorous, unique style, and they will soon find gagmen with whom they can collaborate on ideas and captions. Some publications like *The New Yorker* and *Playboy* will buy and provide ideas for those artists who have a talent for humorous drawing. At any rate, competent comic draftsmen can always obtain work in the ever-widening field of cartoon advertising and comic illustration for magazines and books.

Here are several types of gags that cartoonists originate, and the devices for turning these gags into humorous, completed cartoons.

Surprise Ending Picture

Multi-panel pantomime cartoons are always popular with editors and usually command higher prices. They vary from two to six or eight panels. The first panels are played "straight." The surprise, the unexpected, takes place in the very last panel. In thinking up his idea the cartoonist usually visualizes the last panel first. He then builds up his continuity in the first panels to lead to that big bang at the end.

Make your own collection of this type of cartoon from newspapers and magazines. Then, cover the last, the surprise panel. Study the first panels and see if you can think of another ending, one that will top the original.

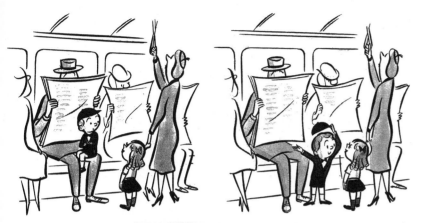

"I've been asked to get married twelve times—all by my father."

With this same picture, you could very easily use other captions such as, "The only thing standing in the way of my getting a divorce is I'm not married to him yet."

Reverse Gag

This is a reverse of the usual situation of Easterners reading Westerns. This type of gag is used a great deal in magazines.

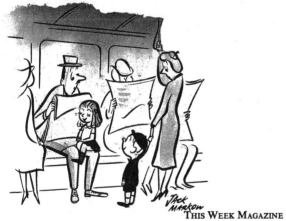

THIS WEEK MAGAZINE

Surprise Ending Caption

This is purely a conversational type of gag. The gag line is all-important. The picture merely establishes the characters and setting. The first part of the caption starts conventionally enough; the latter part of the same conversation piece contains the twist, the surprise.

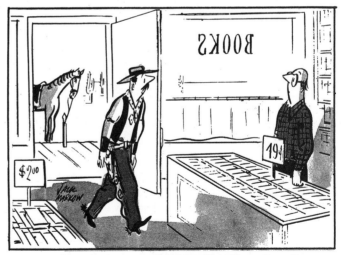

THE NEW YORK TIMES BOOK REVIEW

"I'm gittin' bored, Tex. Got any good 'Easterns'?"

Another reverse gag in three-panel form. Boy hits top hat. Top hat hits boy. This cartoon also combines the qualities of a gadget gag, a cliché picture gag, and a surprise ending gag.

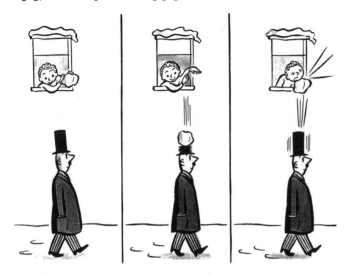

Cliché Picture

You've seen hundreds of cartoons on these subjects, and you will see many hundreds more in the future. Despite the fact that these items have been run into the ground, editors will always buy picture clichés if a *good, new, fresh* variation on the theme is presented. Magazines use them continually.

Some of the clichés in *picture* form are as follows:

Note in milk bottle	Ladder—two people eloping
Man reading eye chart	Operating theater of hospital
Crystal gazer	Father playing with son's toys
Tunnel of love	Neighbor borrowing cup of sugar
Desert island	Woman being fitted for shoes
Bed of nails	Diner annoyed at slowness of waiter

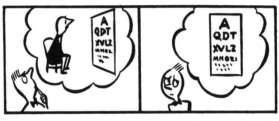

Cartoon based on eye chart

The idea for the cartoon based on the eye chart was evolved by first studying the normal eye chart situation. Then followed concentration on the eye chart itself—trying to think of something to replace the varied-size letters. Musical notes finally came to mind as a substitute for the usual printed letters on the chart.

Cliché Caption

Gags based on clichés always have good sales value. True, these expressions are old, but a good, fresh, surprising picture coupled with that familiar remark will produce a funny cartoon.

First, make up a list of clichés for study. These may be culled from conversations overheard, radio and television programs, books or newspapers.

"Listen, Helen. They're playing our song."

Other versions of the same cliché as the one shown above:

Snake charmer playing his instrument, two snakes emerging from basket.

One snake to the other, "Listen, dear, he's playing our song." Stout couple lounging in deck chairs. Ship's steward ringing dinner chimes.

Portly man to wife, "Listen, darling—he's playing our song!"

These clichés may be used in their original form, or changed slightly.

"Try this one for size."
"Everything's in ship-shape order."
"Go away and never darken my door again."
"Woman's work is never done."
"Mind if I look over your shoulder while you work?"
"Don't keep me in the dark."
"It isn't polite to point."
"I'm a stranger in town myself."
"You should have seen the one that got away."
"He's in conference."
"Having a wonderful time, wish you were here."
"We're just made for each other."

The Gadget Gag

You can develop a gadget gag by studying props and observing how they work. Pictures in mail-order catalogs, photographs and drawings of furniture, household appliances, and other props are studied by the

THE NEW YORKER

33

cartoonist, and a logical misuse is found for them as a basis of cartoon ideas. The shape, the size, the movement, and the relation of these props to human beings are studied. This is a real *visual* aid to gag making.

For instance, musical instruments are funny-looking objects just as they are, and when put to work in a way never intended by musical-instrument manufacturers, laughs will result. We have trombones with slides, music stands which can be raised and lowered, cymbals which bang together, drums which look like tables or soup tureens, horns with intestine-like coils, violins that nestle under the chin, xylophones which resemble ironing boards, and harps which look like bed springs. In addition, the musicians playing these instruments look so serious when performing that we have ample material here for satirical drawing.

Gags Based on Signs

In this cartoon the literal use of the sign brings forth the gag.

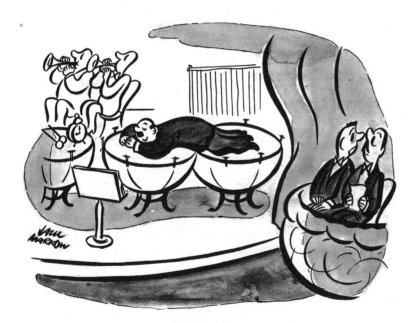

THE SATURDAY EVENING POST

"He has a one hundred and sixty-eight bar rest."

TRUE

Here the usual sign is given a reverse twist.

34

THE COMICS — A BROAD PICTURE

A HUNDRED MILLION AMERICANS read the comics every day—and so do several hundred million persons abroad. This, as you know, is made possible by the syndicate, the distributor of the cartoon to many newspapers. Through this syndicate device a *Blondie* sequence, for example, may appear in 1500 papers on the same day.

Scanning the daily comic pages, one is impressed by the variety of their makeup. There are cartoon comic strips which range from the extremely burlesque to a more restrained style; the serious strips may be totally realistic in drawing, but there are some semirealistic ones, and occasionally these mix humor with a straight story. The single panel may range from a zany Bill Holman work *(Smokey Stover)* to the photographically drawn *Believe It or Not.* The sizes of these features vary and so do the contents. The production may include a puzzle-a-day, a gag-a-day, or weekly episodes strung out into a two-month's sequence.

A Short History

Stories graphically displayed in sequences are as old as the hills. Drawn in a symbolic style not far removed from modern work, they can be seen on cave walls about 30,000 years old, on Egyptian scrolls dated 1000 B.C., and in strips on Greek vases of 500 B.C.

Caricature and satirical drawing developed through the centuries and were brought out in print collections by such geniuses as Francisco Goya and William Hogarth. Cartooning got a big boost with the development of lithographic reproduction and multiple printing in the middle of the nineteenth century. In Europe, such giants as Honoré Daumier, George Cruikshank, and Sir John Tenniel were able to display their talents regularly to the masses; in this country, cartoons by Thomas Nast, Homer Davenport, and others, constantly appearing in the news weeklies, heavily influenced public opinion.

The comic strip for mass consumption is a twentieth century phenomenon. It is a method of storytelling that has been refined, enlarged, and variegated by specialists, principally in the United States. While cartoons in multi-panel form had been appearing occasionally in funny weeklies, it was a six-panel cartoon, *Hogan's Alley,* by R. F. Outcault, in the *New York World,* that led the way for newspaper color pages. The first continuing strip was a Sunday feature—*The Yellow Kid,* drawn by the same Mr. Outcault. By 1896, the *New York Journal* was running eight full pages of comics in its color weekly; these included *The Katzenjammer Kids* and *Happy Hooligan.* Other early classics among Sunday pages were *Foxy Grandpa, Little Nemo,* and *Buster Brown.*

The first daily strip in black and white was a 1907 opus, called *A. Mutt,* by Bud Fisher. It later became *Mutt and Jeff.* Then followed a vast parade of distinctive daily features. Among these were: *Bringing Up Father, Krazy Kat, Boob McNutt, Barney Google, Winnie Winkle, The Gumps, Little Orphan Annie, Popeye,* and others.

In the 1930s, there occurred a great breakthrough in comic strip content. *Tarzan,* the first adventure strip, was born, and the "pow-splat-thwok" school of strip cartoonists took over many of the spots on the comic pages. Up to that time, strips were *comic* in the true sense of that word, with plentiful gags sprinkled throughout the feature. The adventure, or story, strip depends on straight narrative, cliff-hanging suspense, and a long, continuing story line. It is a combination of novel writing and realistic illustration fitted into the strip format. Favorites then and now are: *Terry and the Pirates, Steve Canyon, Dick Tracy, Joe Palooka, Flash Gordon,* and *Prince Valiant* drawn by Harold Foster who originally started *Tarzan.*

In recent years, syndicate strip purchases have leaned again towards the comic. These newer strips employing simple, crisp techniques include *Beetle Bailey, Dennis the Menace, Peanuts,* and *B.C.* Some of these modern features, such as *Pogo, Jules Feiffer,* and *Li'l Abner,* reflect current events.

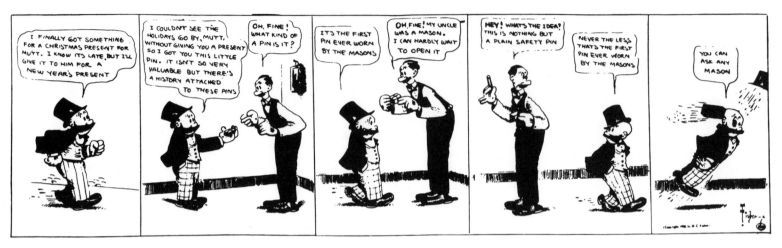

an early *Mutt and Jeff*

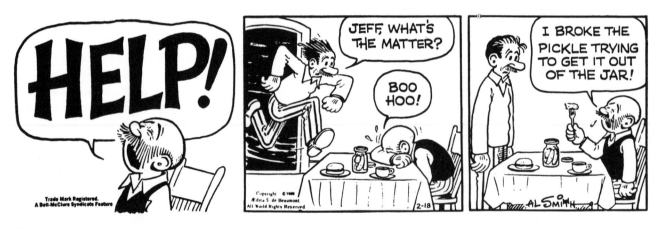

how they appear in today's papers

Mutt and Jeff, the first daily strip, has appeared in newspapers for over sixty years. Bud Fisher, its inventor, produced this feature for several decades. Al Smith continues the adventures of this durable duo at the present time.

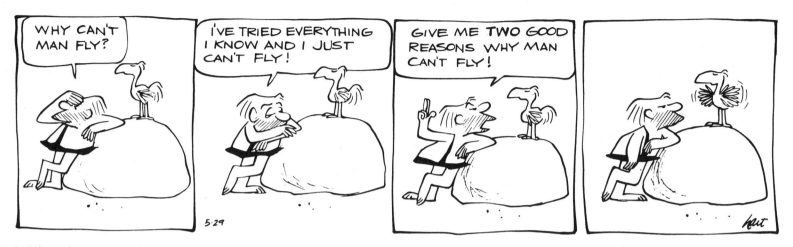

B.C. by Johnny Hart is one of our newer strips. Although based on ancient times, its drawing, technique, and ideas are very modern.

Comics as a Career

The comics are liked by everyone, and especially by those with a flair for drawing. The school child with this talent gravitates to the comic page and copies his favorite characters. Later, in high school or college, he may try something of his own for his school paper. Then finally bitten, he may want to seriously crack this funny profession. It is not easy; the drawing in most comics may seem simple, but the most abbreviated style is the result of much work and study. And the carrying out of ideas and continuity for many years takes a bit of organization and genius.

For those of talent, willing to toil and study, the rewards are endless. Firstly, it is a "fun" profession. Your feature is solely your own and you are the director of it. Once established, you edit your story and ideas with little outside interference. You create the characters and build up their traits. Your comic can be a long-running production. For example, *The Katzenjammer Kids*, *Bringing Up Father*, and *Mutt and Jeff* are still alive and well after six decades; many other characters are still going strong after thirty or forty years. It is a career that can be peformed at the age of seventy as well as twenty, and it is work which can be done in the section of the country (or world) of your choice. You are your own boss—providing you meet the deadlines. As for the monetary end, the sky's the limit. Top comic men earn six-figure yearly incomes. Residuals add up. *Peanuts*, for example, is reputed to gross millions of dollars a year in merchandising and other residuals: books, records, TV, plays, greeting cards, sweat shirts, pillows, dolls, etc. Not all comic artists end up as stars, of course—but most make a comfortable income for life.

CREATING CARTOON CHARACTERS

THE SINGLE PANEL, the daily strip, and the Sunday feature are three formats offered for syndication. Whichever the cartoonist chooses for expressing himself, the chances are he will want to devise set characters for his feature. (While there are some comics without continuing characters, the majority are built around a set cast.) Before diving into this area, the beginning cartoonist should have the basics of funny drawing at his fingertips—the shorthand and symbols for constructing cartoon faces and figures. This is found in *Drawing and Selling Cartoons** and it is the start of comic strip characterization for the funny papers.

In devising a feature, first on the agenda is the choice of a general subject that the artist knows. Next comes the physical and mental formulation of the feature's personalities. Attempts should be made to build long-lasting, durable people, understandable and appealing to a wide audience. There should be enough characters (main and subsidiary) so that, for a change of pace, one can sometimes take over the feature for a sequence or two. Note Snoopy's role in *Peanuts*.

In selecting these individuals, *contrast* is a big help—differences in their outward form and in their inner workings. Their makeup, both physical and mental, affects the idea making that goes with the strip or panel. Contrast is something that reaches way back in strip history. A good example is *Mutt and Jeff*—Mutt tall, Jeff small. And what more diverse characters can there be than in the classic *Krazy Kat* strip—a cat, a mouse, and a dog? A recent best seller, *Andy Capp*, features a skinny husband and a plump wife.

*Jack Markow, *Drawing and Selling Cartoons*, rev. ed. (New York: Pitman, 1964).

Individual Characteristics

Each character should be created as a unique individual, different from the people in other strips. Simplicity of drawing is a big factor; this enables the character to be readily recognized whether drawn small or large; it also eases the drawing chore from panel to panel, aiding the artist who has to show him in all positions.

The illustrations that follow indicate some of the details that can make a character outstanding. Among these are the type of eye, nose, and hairdo. Noses and eyes, for instance, may be the same on all the artist's characters. This helps create a style—and people may say: "That's a cartoonist Jones nose," or "That's a typical cartoonist Brown pop eye." These facial features can also vary within a strip—the changing of feature symbols to fit certain types. Take your choice. Also shown is how clothing, and how it is worn, can pinpoint a character—the loudly patterned suit, the short or baggy trousers, the kind of hat. Foibles creep in and are effective. For example, Andy Capp wears his cap and has a cigarette butt dangling from his lower lip no matter what he's doing—sleeping, lounging, talking, playing football; Mort Walker's Beetle Bailey always has his headpiece tilted over his eyes—his eyes are never shown. These are some of the things that should be considered when originating the *appearance* of a character—inventions that will insure his uniqueness.

Construction of characters must be taken seriously. The artist himself must be intensely interested in his funny people. Once set, they may be with him for a long time.

BODY FORMS

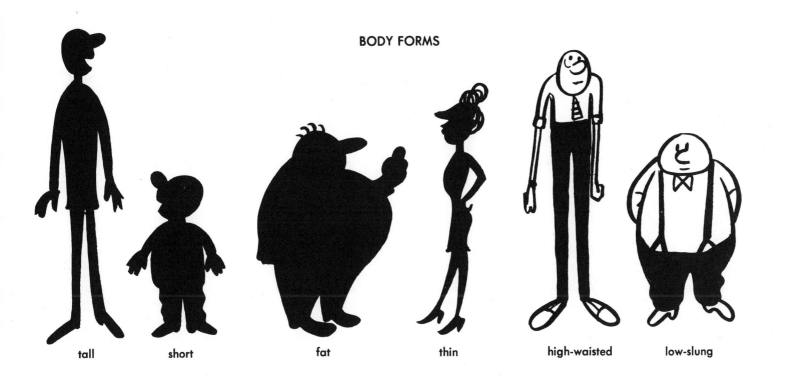

tall short fat thin high-waisted low-slung

HEAD SHAPES

round egg square oval flat

39

FACIAL FEATURES

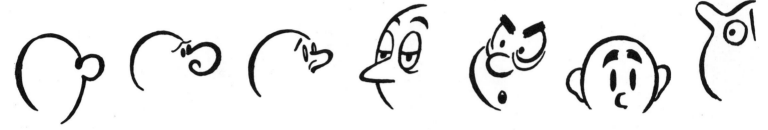

eyes—from pinpoint to pop

large and small ears big mouth purse mouth hidden features

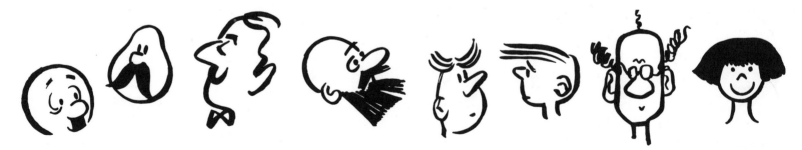

face and head foliage

ACCESSORIES

 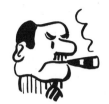

Eyeglasses and smoking equipment hats—tiny and big

DRESS

 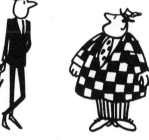 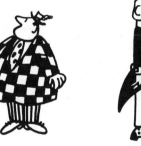 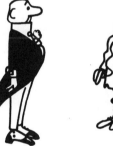

shoes—ample and petite conservative flashy old hat sloppy neat

KIDS PETS

Characters in All Positions

After the comic character has been established, the cartoonist should practice drawing him from all angles and in various sizes. The artist, possessing a well-planned character with distinctive facial features and easily distinguishable body shapes and proportions, will find it easy to make recognizable repeats of this comic actor. Once simple head and body shapes have been set, they can be used in all positions with little change. Strict ob-

servance of proportion (size of head in contrast with body size, the placing of features and their dimensions) is also a key to the duplication of figures. Mechanical means such as the horizontal guide lines in these illustrations may have to be used in the beginning. Repeated drawing exercises in this area will result in good look-alikes freely penciled in.

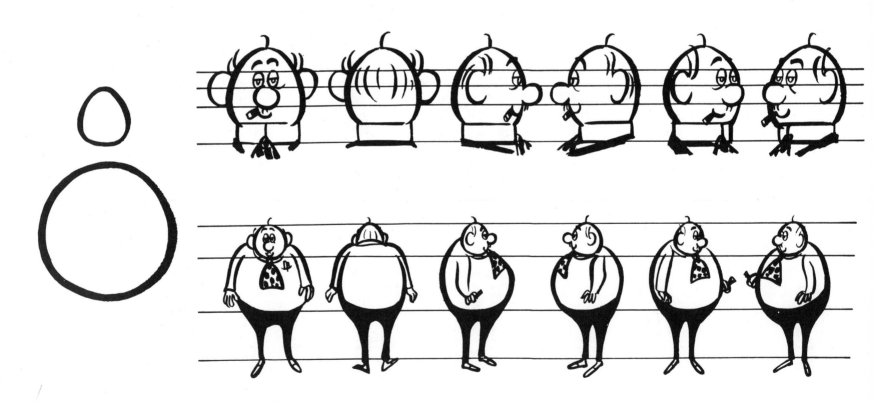

CHARACTERS BRING IDEAS

A FUNNY DRAWING may be an aid towards a laugh but it is a big nothing, lacking an idea. The average feature consumes about 300 ideas a year and that takes a lot of brain work. The comic strip artist, in cleverly constructing his characters, leans on them considerably in garnering his yearly quota of daily episodes. The inner workings of the character's mind—his routines, his quirks, and his hobbies—become the foundation for a great deal of strip material. Characteristic traits, once established and known, become a constant theme with variations. In show biz, note the mileage attained by Jack Benny over the years in his role as a penny pincher. In comic strips, we have Andy Capp, the lovable, lazy slob who never does a day's work; also, Charlie Brown who never makes it as a baseball player. A character may be a braggart or a timid soul, conceited or modest. He may be avid for certain foods, as with Popeye's need of spinach; or he may be engaged in hobbies such as flying pigeons, golf, TV, and bird and girl watching. Mix these traits with everyday happenings and you come up with ideas—not usually those of the slam-bang, concocted-joke variety, but those with natural, quiet humor. In short, the overall personality patterns of the comic strip's occupants furnish much of its wit.

There are, of course, syndicate features that depend on more contrived humor. These are single panels with their one-line quips and some strips that make it each day with a socko punch line. "How do cartoonists get their gags?" is a common question. Each has his own method. One will stare at a blank wall and concentrate on situations; another will team up with a few gag-minded individuals and have a gag session; still another will use visual aids—photos and published cartoons—to spark ideas. There are many stimuli, starts, or jumping-off points for idea creating, too many to show in this small space. For homework on this vital area of cartooning, consult *Drawing and Selling Cartoons* and *Cartoonist's and Gag Writer's Handbook,* both by this author.* These books show various types of ideas—the gadget, the surprise

*Ibid.; Jack Markow, *Cartoonist's and Gag Writer's Handbook,* (Cincinnati: Writer's Digest, 1967).

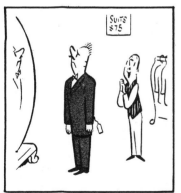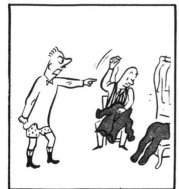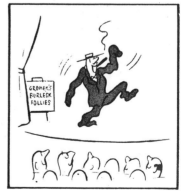

The idea for this pantomime strip is based on the "reverse twist" contrivance.

ending, the cliché, the reverse—and other devices that will bring ideas. Study of published strips and panels past and present (a pleasant task!) is essential to learn how artists have conceived their characters and how the comic line or story is handled from day to day and from week to week. Newspaper microfilms, available at some libraries, plot the relatively short run of The Comic (only seven decades) and give you the continuing stream of strips from Buster Brown to Charlie Brown.

MATERIALS FOR THE COMIC ARTIST

DRAWING SUPPLIES for the newspaper cartoonist need not be elaborate. His is an uncluttered medium using undiluted black and white with little or no subleties of tone.

If he can stake out an entire room for a studio—fine! Otherwise, a corner of a room near a good window light is sufficient. The best light is one free from sun glare. Artificial lighting serves the purpose for many comic men. Household floor or table lamps with good wattage may be used for this. Special artists' lamps with swinging arms are very good and may be picked up by the beginning artist when he reaches some affluence.

The drawing table becomes the artist's headquarters. Some prefer the standard artist's table that can tilt, swivel, and perform all sorts of rotations. In using this, a smaller table is needed to hold art materials. Many like a flat table or desk; here, the table top efficiently holds the working materials. The cartoonist's furniture includes a filing device to hold research material, cartoon proofs, etc. This may take the form of simple cardboard cartons at little expense, or steel files—when the checks start coming in.

Mechanical requirements—squaring, ruling—make a drawing board a necessity. The owner of a professional drawing table may work directly on the table surface, tilting it to suit his particular angle of working! More often, he employs a drawing board set on top of the table. The desk or flat table man *really* needs a board; he rests this against the table edge using his lap as an anchor in getting the right tilt. The average all-purpose board size is 18″ by 24″; those who like to work larger will, of course, buy a larger board. Other mechanical tools are a T square, a ruler, a triangle, a ruling pen, and a compass with pencil and pen attachments. These are the materials that will help line up the lettering and complete the frames of the comic strip.

Small pads of paper for jotting down ideas and larger ones for preliminary sketches are the next purchases. For finishes, two- or three-ply bristol board of good quality are used. The surface is important. Plate (or smooth) is principally used by pen men; Medium, kid finish (with a slight tooth or roughness) is the brush man's favorite. To attach the paper to the board, thumb tacks or the more efficient masking tape are employed. Pencils of medium softness are used for sketching. These may be the stationers' no. 2 or no. 3—or artists' pencils 2B or 3B. An inexpensive pencil sharpener is a time-saver.

Most comic strip men prefer the pen for finished drawings. Ordinary writing pens are used by some; artists' drawing pens by others. Gillot 170, 290, and 303 are some of the points professionals use. For balloon lettering, the Speedball A-5 or Esterbrook Probate no. 313 works well. Speedball points B-3 or B-4 are used for heavier lettering. At least two penholders are necessary. Pen artists also need a good sable brush, no. 2 or no. 3, for filling in solid blacks and a no. 1 or no. 2 for making corrections with white

paint. Brush men will use a no. 1, no. 2, or no. 3 for cartoon outlines. And, of course, don't forget the bottle of black, waterproof india ink.

Add a pencil eraser (kneaded or gum) for cleaning up, an ink eraser for corrections, and a small jar of poster white for the same purpose—and you're in business.

These are your key materials. Special tools will be indicated further on in this book.

INK OUTLINES

THE CRUX of the drawing made for reproduction is the outline. Indication of the outline, whether done with pen or brush, brings out the characters and the setting. The added solid blacks, textures, and designs are just embellishments which make the picture more appealing but are less important than the impact of the outline. The special concern of the newspaper cartoonist is, first, that his line will reproduce well and, when reduced, provide a close facsimile of the original. His second interest is that this line will have an individual quality.

While names and numbers of pen points have been suggested here, the embryo cartoonist is advised to experiment with various nibs until he finds the one just right for him, the one with which he can work easily, speedily, and efficiently, and the one which will give him a strong, clear outline.

The one brush (whether it is a number one, two, or three) will give you a variety of lines—light, heavy, and a range from thin to thick.

THE PEN
Here are some reproduction results using a variety of points:

1. Hunt no. 108 (flexible).
2. Gillot 303 (pliant).
3. Gillot 170 (fairly pliant).
4. Thin nylon marker (rigid).
5. Rapidograph fountain pen (rigid).
6. Speedball B-6 (rigid).

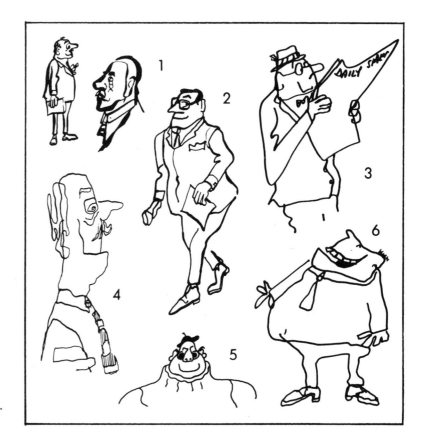

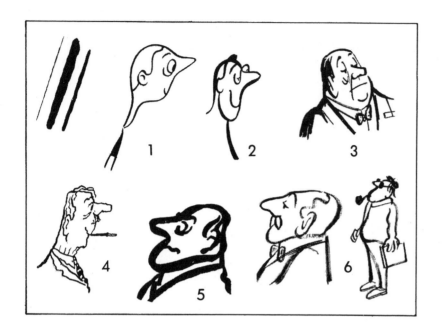

THE BRUSH

Note the different lines produced by a no. 3 Winsor and Newton red sable brush:

1. Flowing line (apply even pressure to the brush).
2. Variety within a line (apply various pressures on the flowing line).
3. Choppy line.
4. A nervous line (just wiggle the brush).
5. Fat, bold line (press hard on the brush).
6. Dry brush (half-dry the brush on blotting paper or newsprint before applying).

LETTERING

LETTERING is all-important in the comic strip product. It conveys the idea, message, or story. To many artists it is a tedious stint compared with the exciting happenings in the pictorial part of the strip. When they can afford it, many syndicate men don't hesitate to hire a lettering specialist to relieve them of this task. However, some like to do their own lettering, feeling that their balloon style ties in nicely with the character of the strip as a whole. The newcomer, usually lacking the wherewithal for an assistant, must do all the work in launching his feature. With practice, balloon lettering can be performed as easily as writing, it *can* be fun, and for the beginner it can be extremely satisfying as he sees *his* style emerging.

Above all, balloon lettering must be legible. It must be easily read when reduced and reproduced from the original; it cannot be crowded. Therefore, cartoonists, to guarantee sufficient space for these words, usually put the lettering in first, and show the exploits of their cartoon characters in the remaining space. Balloon lettering is simple; it is done with single strokes of even thickness, employing capital letters without serifs (lines added to the basic letter strokes for design effects). As you study the comics, you may find that a few depart from this formula. One may use lower case letters; another may slightly slant the lettering; still another may combine thick and thin strokes—but these are the rare exceptions.

Key points to consider in this task are: the shape of letters; the space between letters; the space between words; the space between lines of lettering; the space between a block of lettering and its balloon; and the shape of the balloon. The best way to practice any form of lettering is to first study printers' type. This gives you an idea of a letter's basic construction and from this point you can go on to find your own style.

ABCDEFGHIJKLMNOPQRSTUVWXYZ
123456790 (&$!?:;:;-)

An example of printer's type is valuable as an aid to shapes of letters.

ABCDEFGHIJKLMNOPQRSTUVWXYZ

Practice your alphabets adding looseness and style.

Crossbars work best for reproduction when they are close to the center of a letter.

RIGHT WRONG

For readability, letters should be wide rather than thin and skimpy.

(a) (b)

Letters set mechanically in type may produce awkward spacing (a). In hand-drawn lettering (b), letters may be overlapped for even spacing between letters. The *area* between letters is important.

Typical proportions for balloon lettering. Spaces between lines of lettering are one-half the height of the lettered words.

DEVELOP YOUR OWN STYLE OF LETTERING

Lettering is bunched into a block with ample space from the mass of lettering to the balloon outline.

THE SINGLE PANEL

MANY CARTOONISTS choose to work in the one-panel medium simply because they like this format. Some may be recent refugees from the magazine field where they functioned in the condensed picture–terse caption area; they are more at home applying these familiar skills to syndication. Certainly, less time is spent at the drawing board in producing single panels than in the doing of strips with their repetition of pictures and with the added chore of balloon lettering. Some prolific artists can achieve their weekly quota of six panels in two days.

Many syndicates have the theory, however, that the strip form generally brings in greater revenue than the panel—that because of the former's larger space and continuing story line it is less likely to be dropped by a newspaper. Nevertheless, these firms buy many single panels. The reason? They are space savers, they offer variety in the comic pages, many make money, and some, like *Dennis the Menace*, reach the top ten in syndicate sales. Your choices in the matter of panel versus strip are: Which medium do you like best? Which is the one more adaptable to your talents? How high up the income ladder do you want to climb?

Format

The single panel (two column), as it appears in most newspapers, has the proportion of a simple square. The original drawing is usually done twice up, 7½″ by 7½″ (that is, 3¾″ by 3¾″, times two). However, the artist, depending on what working size is easiest for him, may make the original slightly smaller, 6″ by 6″ or 7″ by 7″, or a bit larger, 8″ by 8″ or 9″ by 9″. The caption is indicated clearly in pencil or ink beneath the drawing and it is eventually set in type. A few one-panel features based on multiple conversation (*They'll Do It Every Time* and *Our Boarding House*) use balloons which are worked into the picture, with no printed caption necessary.

The *Laff-a-Day* format shown here does not include a border but usually the panel cartoonist utilizes some kind of line around his drawing to set it off from the other features that may be crowded together on the comics page. The simplest and easiest device is the ruled border of various thicknesses, done with the ruling pen. Some artists strive to achieve a little added distinction for their panel and depart from the mechanical squared-off shape. One will use a circle (Bil Keane for *Family Circus*); another will render a freehand frame (Hank Ketcham for *Dennis the Menace*); still another will round off the corners (Virgil Partch for *Big George*). A small item, but one of the many gimmicks dreamed up by the comic man to help make his little corner of the comic page different.

Certain newspapers lacking space may use the single panel in one column and sometimes lop off the sides of a cartoon. The reproduction then appears in almost postage-stamp size—all the more reason for the artist to get strong outlines and contrasting blacks into his original drawing. Space savers also include some single panel features that are wider than high (3¾″ by 2½″).

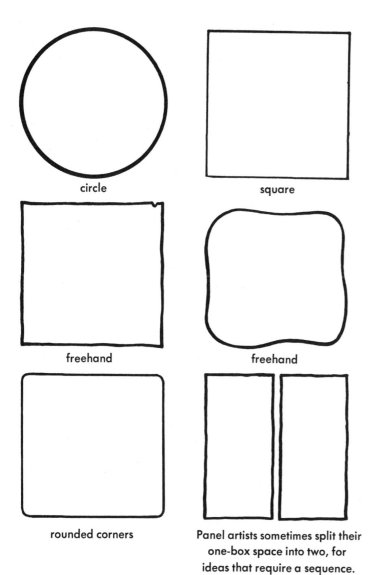

circle

square

freehand

freehand

rounded corners

Panel artists sometimes split their
one-box space into two, for
ideas that require a sequence.

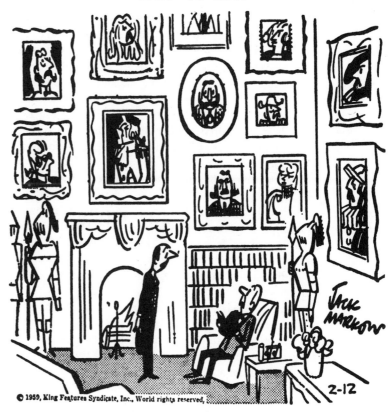

"May I see you alone, sir?"

Content

There is an endless variety of single panels. The gag-a-day type may be one put together by the syndicate using cartoons purchased from various free-lance artists. McNaught's *This Funny World*, King's *Laff-a-Day* and Chicago Tribune-New York News' *Today's Laugh* are examples of these panel parcels. The feature using a general idea each day may also be a single contract cartoonist's effort. Here the gag poses the problem—not the drawing, which can be relatively simple. More than in any other area of the comics, it is these gag-a-day cartoons (unsupported by characters and continuing story) that require a good, solid, top-notch idea each time out. Men who work in this area, barring the few who are extremely gag-talented, find it difficult to produce their 300-odd idea gems each year; when their panel begins to make money, they invariably buy ideas from gag men. Among the syndicate's total wares, this individualistic segment of the comics provides a small percentage since there are few men around who can keep a joke panel consistently funny. To add reader interest, some single-panel people introduce a set character into their feature once or twice a week. It is of note that, despite its difficulty, two cartoonists have had much success over the years working in this format: George Lichty with his *Grin and Bear It* and Ed Reed with his *Off the Record*.

In the gag-a-day area, we also have published comics that deal with specialties. There are panels devoted to sports alone, to TV, to the stock market, and to the office. This compresses the idea thinking area even more and one must know these subjects well to be able to continue such a feature. These comics are conceived for newness, for variety, and for possible space on newspaper pages devoted to these subjects.

The single panel using set characters is very popular among newspaper readers. The gag does not need to be as strong (although a good idea is always welcome) as that in the feature which uses different people each day. This somewhat lightens the burden of the cartoonist. Once the daily habits and odd quirks of the panel's little people have been established, an unending

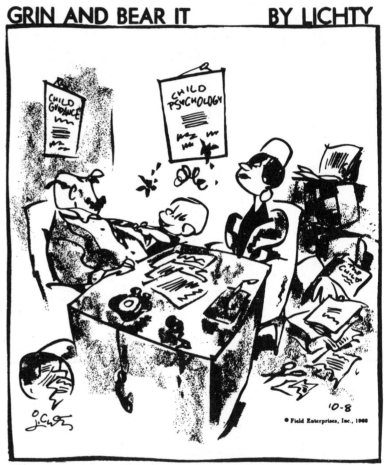

GRIN AND BEAR IT BY LICHTY

"There's no doubt this child is the product of a broken home, madam! . . It's also quite clear as to who broke it up!"

The gag-a-day *without* continuing characters. Lichty uses a wide range of settings, characters, and subjects. His ideas are often topical.

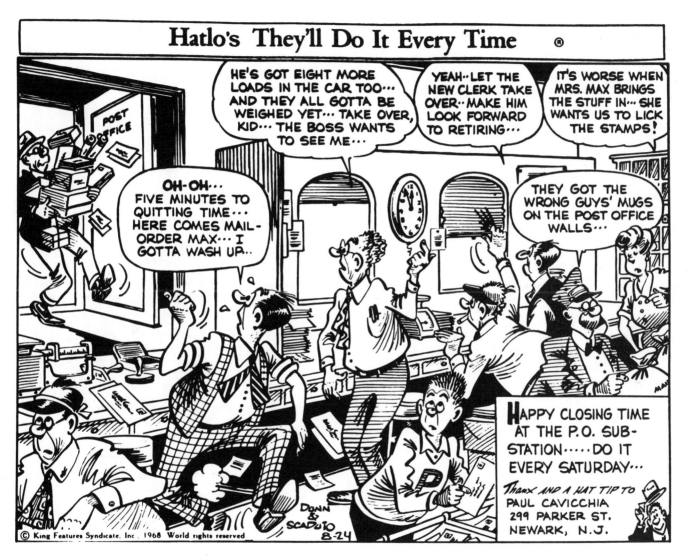

This is a popular, down-to-earth feature which thrives on its bustling activity. Reproduced larger than most single panels, it is really wired for sound. Talk balloons indicate the conversation, as contrasted with type-set quips printed beneath most single panels. This feature was originated by Jimmy Hatlo and has been carried on by Bob Dunn.

stream of "funnies" will result, based on these. Subjects for this kind of panel include general family life, husband and wife, children, teenagers, and animals.

Finally, there are many trick, novelty, and slightly offbeat panels, proving that syndicates are open to new ideas. Among these are puzzles, inanimate objects talking to each other (Jerry Robinson's *Still Life*), and printer's type commenting on life (*PIXies* by Jack Wohl).

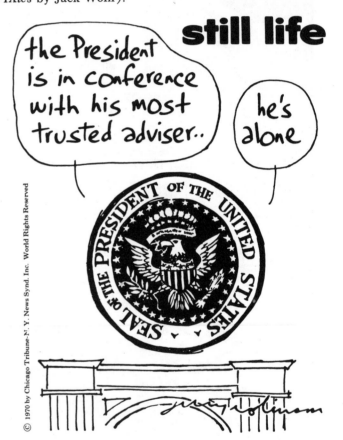

Mr. Mum and his dog roam through this panel each day observing startling happenings. This feature's uniqueness lies in its silence. Captions are never used—a most difficult format to keep going—but Irving Phillips has kept *Mr. Mum* on top of the hit parade for many years.

Still Life, a modern panel by Jerry Robinson, is distinctive in format because inanimate objects carry on the conversation. Also unique is its humor based on timely, topical, and political subjects.

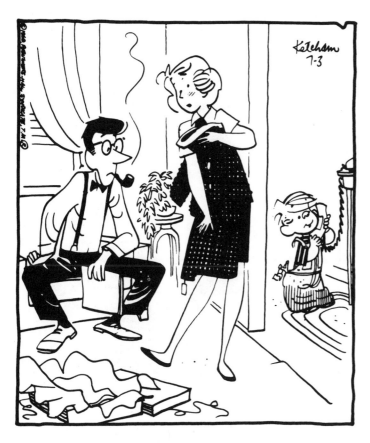

"SURE...SHE'S RIGHT HERE SHOWIN'
US HER *BIRTHDAY SUIT!*"

Hank Ketcham's *Dennis the Menace* panel uses definite characters. Three of the principal players are shown in this example of a parents and child feature which is very successful.

". . . Making eight apples, right? Okay, so along
comes some joker and subtracts one apple.
Now we have . . ."

Ted Key's *Hazel* was a top feature in the *Saturday Evening Post* for twenty-six years. After her successful live series on TV, she is now in newspaper syndication, supported by a large cast including the Baxters, sundry relatives, and pets—a fine family feature.

Steps in Single-Panel Drawing

"Your music makes me feel like we're floating on air!"

1. The caption is jotted down with accompanying thumbnail sketch. Some cartoonists pencil in the drawing directly on the good paper, or finish paper—two- or three-ply bristol board—and proceed with the inking.

2. Others prefer to do their preliminary sketching on a thin bond paper and then transfer the sketch to the bristol board. Corrections, changes, and general messing around are conducted on the work sheet; tracing will result in clean, precise penciling on the finish paper. (The sketch shown was done with a 2B pencil.)

a. Using a light box is an easy way of tracing. The light box, sold at major art supply stores, consists of frosted glass fitted over light bulbs. The sketch is attached to the back of the finish paper, using a strip of ¾" masking tape; it shows through for clean penciling or direct inking.

c. Then the sketch is taped to the finish paper. A hard, pointed pencil (either 4H, or 5H) is used to trace the outlines. While transferring, further corrections can be made.

b. Lacking a light box, another method of transter may be employed. First, the back of the work sheet is covered with pencil dust using a soft pencil (either 4B, or 5B).

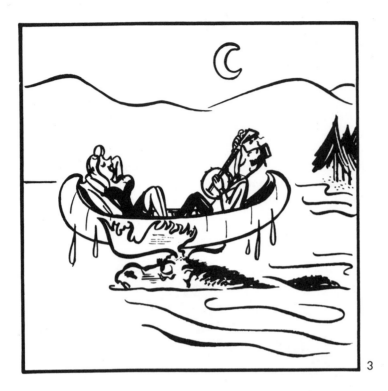

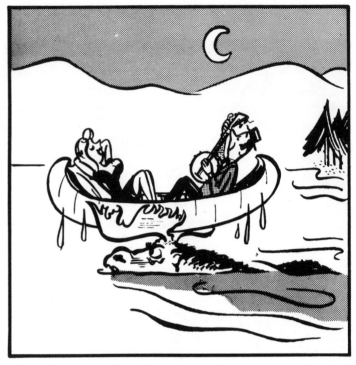

3

4

"YOUR MUSIC MAKES ME FEEL LIKE WE'RE FLOATING ON AIR!"

These are a few of the many patterns available in sheet form, which can be used as designs on clothes.

3. The outlines are inked in with a no. 1 sable brush, solid blacks rendered. The drawing is enclosed with a ruled border.

4. *Ben Day*, a flat, mechanical half tone used by many comic artists, is added to the finished drawing. In some cases, the syndicate art department or the engraver provides this Ben Day; the artist simply indicates where he wants this tone by means of light blue pencil or water color wash on certain areas of his cartoon. More often, he does his own Ben Day work, buying sheets of prepared dot designs and cutting and fitting the design into desired spaces on his drawing. With the addition of the title and caption, the drawing is ready to be delivered to the syndicate.

THE DAILY STRIP

Format

Comic strips when printed may vary in size and proportion, from newspaper to newspaper. Many are reproduced 6¾″ wide by 2⅛″ deep. Cartoonists draw 2 times this size, or 2½ or 3 times this size, depending on how large (or small) they like to work.

In recent years, artists have given themselves more freedom in the construction of each strip. They will use three panels or two panels if this strip division best conveys their story. Sometimes

This is the proportion (the shape) of your working area.

The standard format is one in which the strip is equally divided into four boxes, with space between each box.

Some newspapers will rearrange the boxes and will display the feature in this shape.

one panel will do the job. Fewer panels obviously allow more room for each picture. Varying the number of scenes every few days and departing from rigidity adds interest and gives an individual touch to the feature. Also, some strip cartoonists shun the ruled border and use nonruled, freehand lines around boxes.

A device adopted by many comic strip men is that of showing an occasional scene not bounded by lines. This adds a little air to the strip and at times frees the characters from the bondage of the ruled line. The balloon overlapping from one panel to another helps cut down the rigid line between boxes, aids the flow of the strip from panel to panel, and provides room for extra-long copy by stealing space from a neighboring panel.

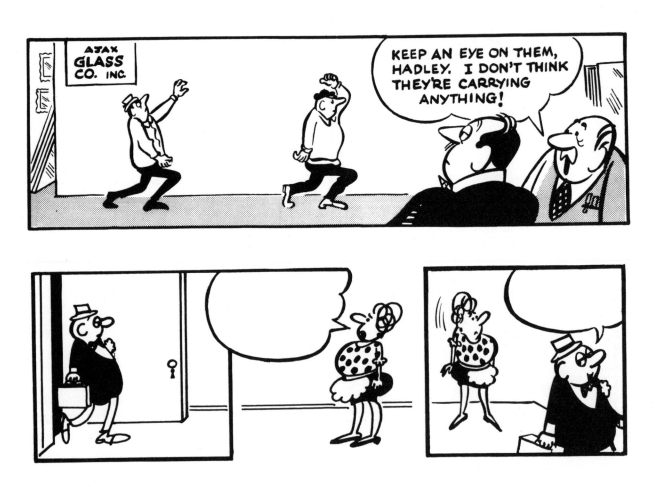

Content

Everyone is familiar with comic strip subject matter. There are many family, husband-wife, and kid features, and a scattering of talking animal strips (*Pogo, Eek and Meek*). There are also features involving such diverse characters as teen-agers, grandmas, orphans, royalty, and glamour girls. Drawing ranges from the bulbous nose–big foot school to the realistic illustration of the story strip, and from no-dialogue pantomime to the very wordy form. This indicates the wide-ranging subjects and various types of drawing open to the beginning cartoonist trying to break into the strip field. New versions of old standard subjects, such as home life, novel departures from material now in use, and fresh presentations, are of interest to syndicates.

These are two daily strips featuring small fry. *Peanuts*, by Charles Schulz, contains easy, natural humor and sophisticated chatter. Sequences on such subjects as Charlie Brown's baseball prowess or the activities of Snoopy the beagle may last a week or two.

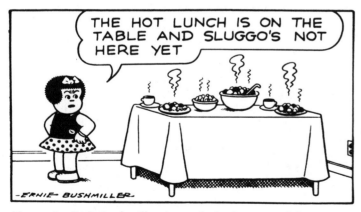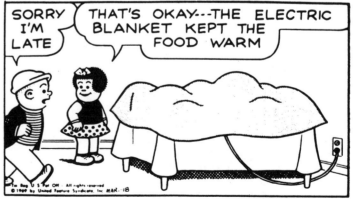

Nancy, by Ernie Bushmiller, is precisely drawn and depends on a strong gag each day, usually of the gadget-gimmick kind as shown here. Occasionally, a theme like Nancy's preparing for a birthday party or for going back to school may involve a week's strips—with a punch line each day.

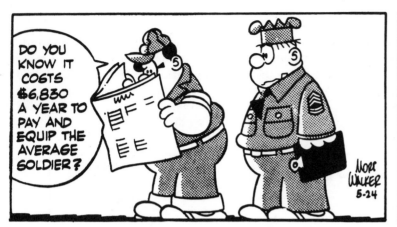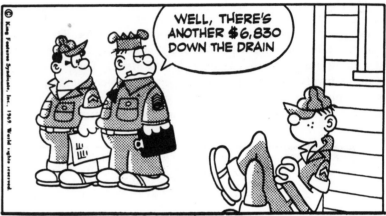

Mort Walker's *Beetle Bailey* is unique in its content and locale—servicemen and army camps. Clearly drawn, containing funny characters and situations, it is among the top ten daily strips in popularity.

THE WIZARD OF ID **by Brant parker and Johnny hart**

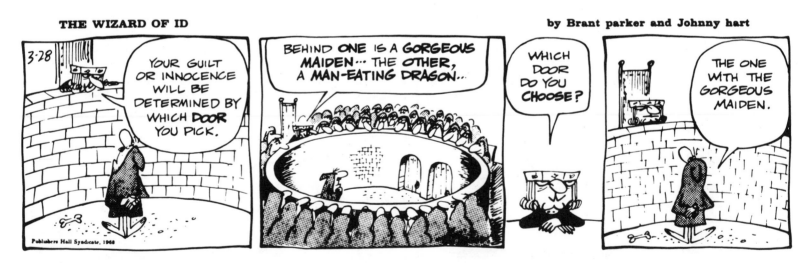

The Wizard of Id, drawn by Brant Parker with ideas by Johnny Hart, is one of the new breed of features A fresh strip subject, nonchalant in format and imaginative in its drawing, it adds a modern touch to the comic pages. Its daily ideas pack a high level of humor.

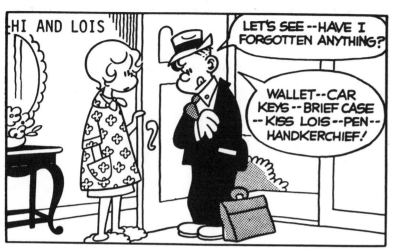

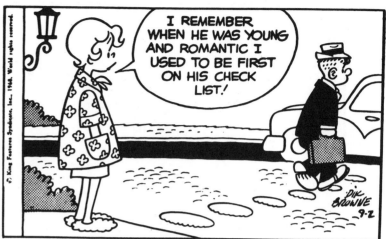

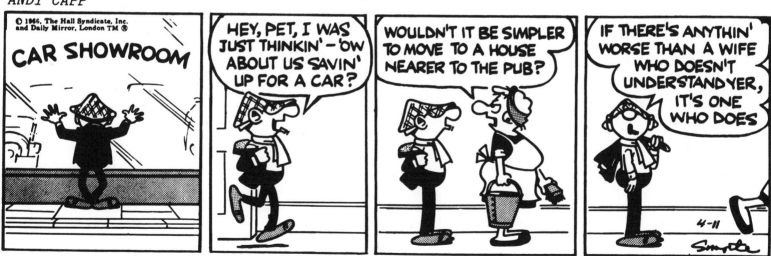

Two husband-wife strips are *Hi and Lois* with traditional family characters, and *Andy Capp* with personalities slightly offbeat.

Steps in Strip Drawing

1. Notation of the idea in rough form.

2. Ruled pencil lines for lettering.

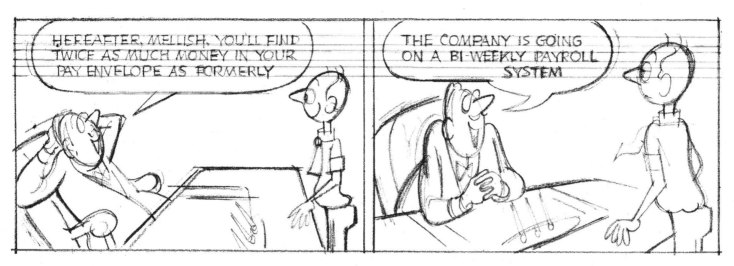

3. Lettering penciled in first—then balloon shapes. Figures are sketched in last.

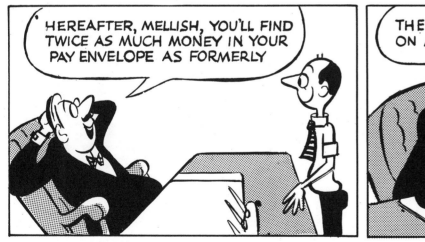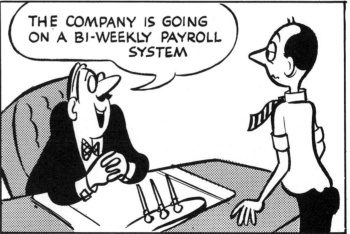

4. Completed, inked drawing with solid blacks and pasted down dot tone.

Drawing Aids

Employing solid blacks is a useful aid in comic art. Black will put punch into the small, compact box space. Distributed wisely throughout the strip, it will add a decorative touch and help make it stand out on the comic page.

If the cartoonist continually presented his strip characters as shown in the upper strip, next page, he would quickly bore his readers as well as himself. He therefore varies his feature from panel to panel using long shots, middle shots, and close-ups

The silhouette is often used by comic strip professionals as a change of pace from panel to panel.

Given such opportunities for its use as night scenes and dark interiors, the artist will take advantage of this gimmick.

Shown on clothes, a block of black provides contrast and brings out an important character.

A black used on a floor makes a solid base, brings figures and furniture together, and helps the composition.

and catches the figures from different angles—the profile, three-quarter and front views, and sometimes the back view.

The close-up helps the overall strip design. In particular, the main character should be shown at close range every so often. This stresses his importance and speeds the reader's familiarity with him.

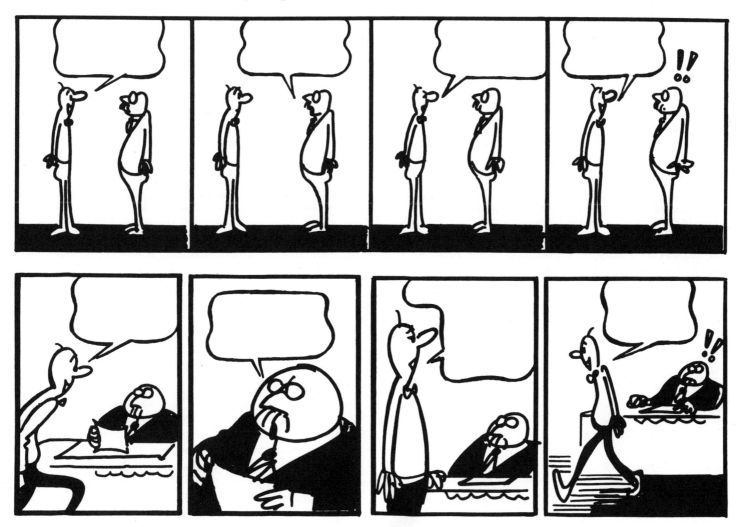

SPECIAL EFFECTS

THE COMIC STRIP MAN possesses many devices helpful in the telling of his story. He has brought a fine sense of improvisation to comic strip art since its beginnings. Many of his inventions may have become hackneyed over the years, but some must still be used; having become part of the comic strip artist's language, they are easily communicable and understandable to his audience. New gimmicks are constantly being devised to speed along gag exposition and storytelling, and these in time may become classic procedures.

Cartoon characters are usually boxed in; they are confined to two, three, or four squares, placed in their own spot on the newspaper page, each day. Perhaps to counteract this fencing-in process, the cartoonist has given his characters extreme liberty in action and expression—has let them exaggerate and overact. Of all graphic artists, the comic strip man is the most uninhibited in drawing and composition. His main concern is to make his product as clear as possible and present it in the funniest way imaginable. Not content with just using the simple drawing and the symbols of the craft (a circle for a head, a dot for an eye, a tomato shape for a nose, a slit for a mouth), he must add a variety of lines, of stars, moons, curlicues, and other trappings—all *outside* his character's head and figure—as added accents for action and expression. In the lively world of the comic people, we also often see straight speed lines, lines to indicate shiny surfaces, and curved lines to accent action or agitation. These elements invented by comic strip artists have helped to make the strip form unique; they have made it possible to "see" sound and extreme movement, among other things, within the flat planes of a comic drawing.

The single-panel artist uses few of the strip cartoonist's devices. He rarely employs balloons; he keeps the expression and action confined within his drawn figures; occasionally he may use a few, discreet action lines. His talk is placed neatly beneath the picture in pristine type. This works well for the single-panel man; one line of conversation spoken solo can be easily conveyed in this format.

The Talk Balloon

Many speakers (as many as three or four in one frame) pose a problem for the comic strip man. This is solved by the employment of the most important device of the comic strip creator—the talk balloon. This built-in device enables him to control the conversation, the proper placement of words belonging to each character, and the right accents and varieties of sound where needed.

Balloons certainly were not new when the first strips began to appear in this country. They are found in fourteenth century woodcuts and in the early nineteenth century cartoons of Thomas Rowlandson and James Gillray. Our comic men, throughout the years, have added refinement and variety to the balloon. Whereas the early balloons looked like vapor emanating from a person's mouth, today each cartoonist has his own style of balloon—circular, oval, or squarish. A short stem or funnel goes directly to a character's lips. The thought balloon, devised by some anonymous cartoonist pioneer, enables the comic artist to delve into a character's cranium and pick out the inner workings of his mind.

Lettering has been straightened out and made more legible,

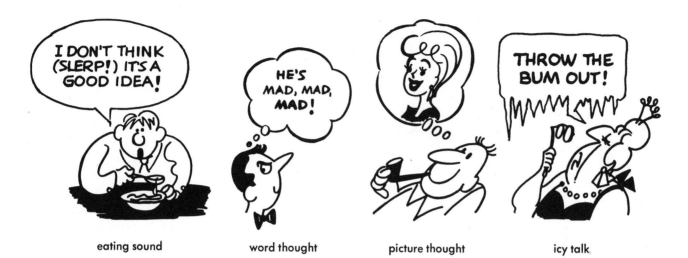

eating sound

word thought

picture thought

icy talk

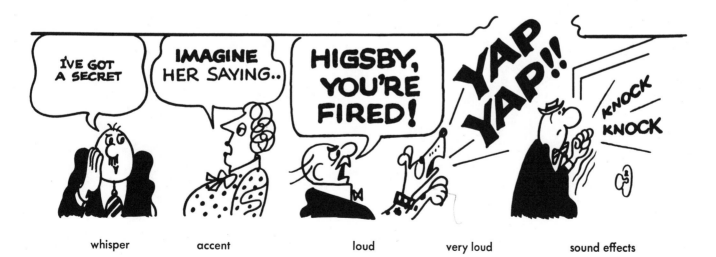

whisper

accent

loud

very loud

sound effects

variety of lines used for action and texture

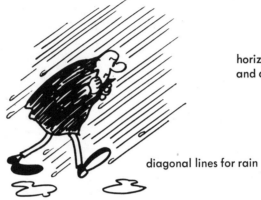

diagonal lines for rain

horizontal lines, curved lines outside wheels, and dust clouds to accent speed

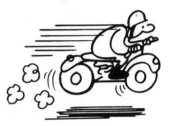

vertical lines for shiny floor

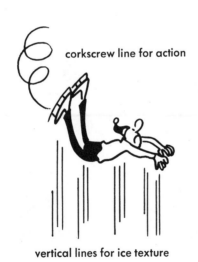

corkscrew line for action

vertical lines for ice texture

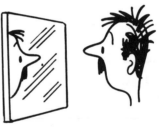

diagonal lines spell mirror

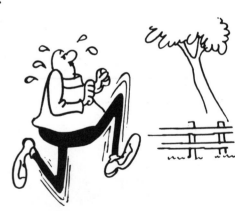

motion lines around legs and sweat symbols for action

and its diversified thickness and size serves to simulate the qualities of sound. Smaller letters mean a whisper, heavier letters accent a word, and large, bold letters convey to us a shout or scream. When a very loud tone is required, the large fat lettering is usually too much for the balloon; then, the artist dispenses with this contrivance and shows the words coming directly out of the character's mouth in fortissimo style. Devotees of the "pow-splat-thwok" school of sound get their effects by exploding these words, liberally sprinkled with exclamation points, throughout each panel.

Action Drawing

In the area of action, the comic strip artist lets out all stops. Drawing a man running, he is not content to confine the action within the figure—with necktie, hair, and coattails streaming back. He invariably lifts his character a few feet off the ground (for better speed and to avoid friction, of course), plunks the inevitable shadow under him to show he is dashing through space, and adds a series of horizontal lines, dust clouds, and sweat symbols trailing the figure. He *is* running—there is no doubt about it. Comic characters are continually up in the air; they seem to have little sense of gravity. A cartoon figure kicked into space really flies, leaving a jetlike trail going back to the shoe that kicked him.

Expression

Comic strip artists indicate expression and emotion very nicely within a head shape. They know the bulging eye, the twitching nostril, the clenched teeth, and the hair standing on end. Going further, they surround the head with familiar symbols, piling on humor and emphasizing the feelings of their little, droll people. These pop-outs may be stars, moons, rays, and corkscrew lines. Another typical expression aid is a question mark of variable size stuck above a poor fellow's head to indicate puzzlement, an exclamation point taking its place when he is excited. An old symbol, still used, is the electric bulb (with rays showing it is lit) hovering over a man's pate indicating "inspiration" or "idea." He is surrounded by contraptions whether he is awake or asleep. The pitiable, tired character is not allowed to indulge in simple slumber with just his eyes shut to show this—he must always be accompanied by z-z-z-z and, sometimes, by an overhead balloon displaying a log being sawed in half. There are also shivery lines, not connected with head or body, denoting fright; large-sized tears gushing forth, for sorrow; and short, straight lines emerging from a lump or bump, to suggest pain. These are just a few of the cartoonist's magical tricks. There are many more, as you will observe when you scan the comic pages. New ones will be originated by future comic strip men when the need for these arises. In the meantime, cartoonists will continue to employ the standard, known devices. How else could they pursue their singular method of communication?

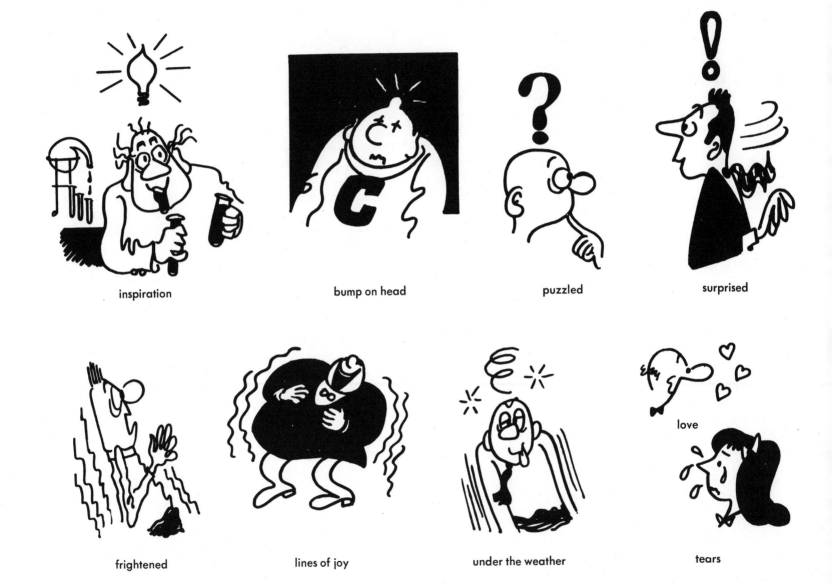

inspiration

bump on head

puzzled

surprised

frightened

lines of joy

under the weather

love

tears

classic fight scene

two kinds of snores

sound of emotion

eye jinks

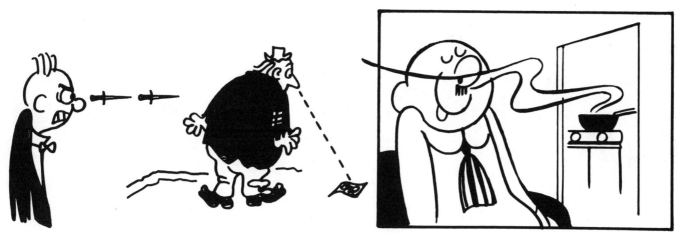

sense of smell

THE NARRATIVE STRIP

THE STORY STRIP is a special segment of syndication. While related to the "comic" strip in several ways (size, panels, balloons, lettering, action), it retains its own identity in its straight story-telling illustrated by realistic drawings. The narrative feature may vary in content from the soap-opera domestic type to that of adventure and fantasy. Continuities may last for several months broken down into weekly segments, each capped by suspense, by means of a cliff-hanging device.

Since the drawing is fairly realistic, most men attempting this kind of strip have had art school training; some have been self-taught and rely on constant sketching. The adventure strip has its special characters—jut-jawed superheros and glamorous girls. Although the drawing is squeezed into small spaces around numerous balloons containing abundant dialogue, the pictures are well executed and done with much detail. The accuracy demanded requires a great deal of research material, usually leading to ample files being kept by the artist. Dark accents, solid blacks, and silhouettes are frequently employed. Boldness and variety of outline are achieved in most cases by the use of the pointed sable brush (nos. 1, 2, or 3). Pen is also used to touch up the figures, and for certain backgrounds.

Steve Canyon　　　　　　　　　　　　　　　　　　　　　　**Milton Caniff**

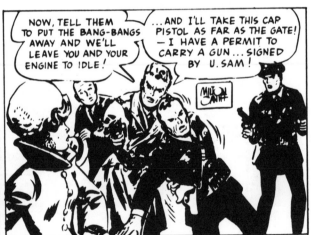

The bold, posterlike style of Milton Caniff is one of the best in the story strip medium.

The Heart of Juliet Jones Stan Drake

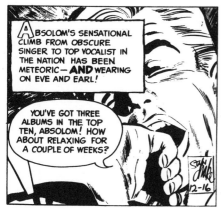 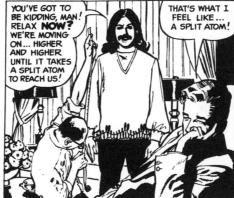 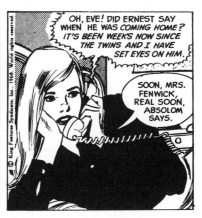

Stan Drake uses fine lines but adds power with his solid blacks. The closeup device adds simplicity and a change of pace to the strip.

Apartment 3-G Alex Kotsky

Blacks make a decorative pattern throughout this strip. Authenticity of props and backgrounds is extremely important in the narrative strip.

THE SUNDAY FEATURE

SUNDAY STRIPS are in most cases extensions of the daily strip. *Blondie,* for instance, appears in newspapers each weekday and reappears every Sunday in living color. There are a few exceptions, features like *Prince Valiant* and *The Little King,* which show up only on Sundays (they never have had a daily counterpart). The easiest road to a Sunday comics contract is to first sell a daily strip or panel; then the syndicate will usually want this feature continued on Sunday. Best bet for the sale of an *independent* Sunday feature is a subject that is novel, offbeat, or specialized (such as puzzles).

Strip reproductions, as seen in the newspapers, vary in size, depending on the area and shape of the individual publication. These papers rearrange the boxes of a strip (called *re-scales*), even eliminating one or two panels not essential to the story, to fit the feature into the paper's space. In the making of a sample presentation, most comic men do original drawings in the horizontal shape shown here. A good size for this is 20″ by 16″. The number of panels varies according to the story and may range from six to twelve.

The Sunday feature format poses a challenge to ambitious strip artists. The working area is large, which allows freedom of layout and variety of panel shapes. There is free play in story display. Color is an added advantage. Working procedure is similar to that of the daily strip. First, a small rough sketch is done for purposes of breaking the story down into panel segments, and planning the size and shape of each box. Then, the lettering and balloons are penciled on the finish paper (two- or three-ply bristol board, as used by single panel artists). The drawing is then sketched in (either directly or traced from rough sketches), com-

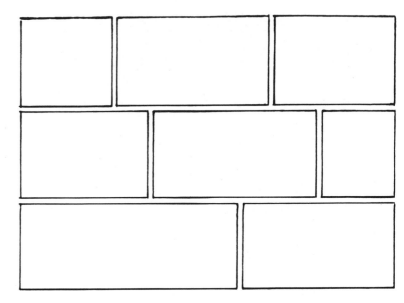

pleting the pencil work. The lettering and balloons of the entire strip are usually inked in first; then the main figures and foreground props; and finally the backgrounds. Solid blacks are applied to complete each panel design and the overall strip design. The original drawing is then photographed or photostated (matte print, nonglossy) down to the size it will appear in the newspaper. The artist follows up by coloring the reduced print as a guide to the engraver. Colored inks or water color are suitable for this.

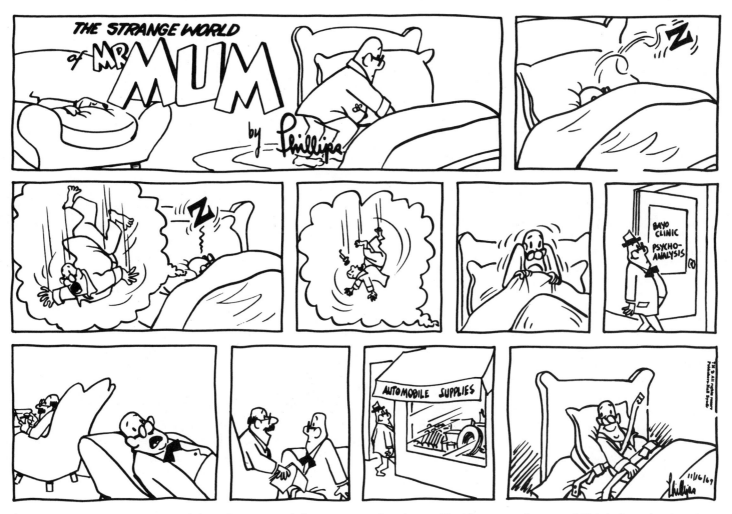

Mr. Mum, a single panel on weekdays, becomes a full size strip on Sundays, still without a spoken word. This is how the drawing appears before color is added.

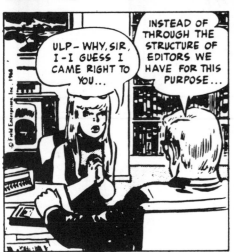

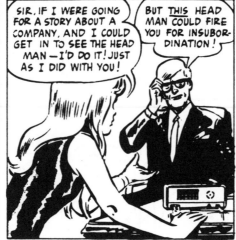

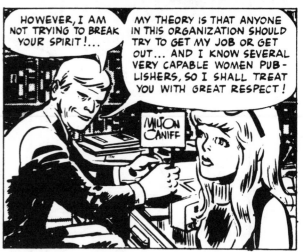

This Sunday feature, *Steve Canyon* by Milton Caniff, was drawn on a three-ply bristol board—original size 23⅛" wide by 17" high. A no. 3 sable brush was used for the figures; a Gillot Crow Quill 659 for fine details.

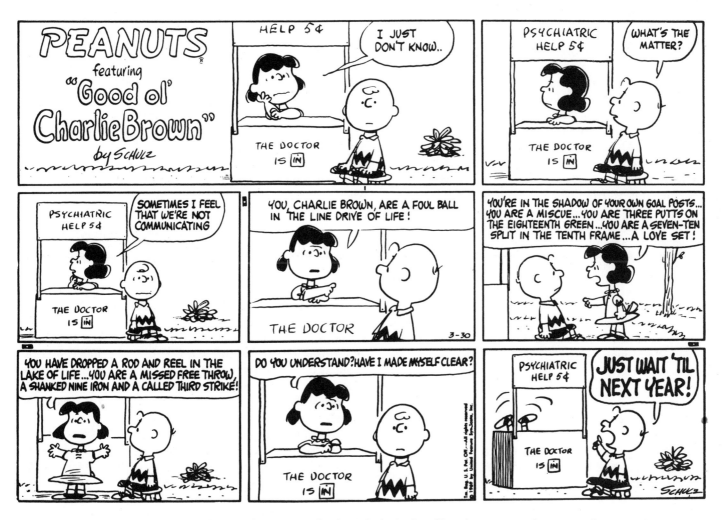

Simplicity of drawing is a mark of this Sunday comic. Charles Schulz thinks of his characters as having real personalities and insists they are very real to him.

PLACING A FEATURE

THERE ARE approximately 250 syndicates, large and small, that distribute features here and abroad. The showing of twelve strips, or twelve panels, or three Sunday strips is all that is necessary to give the syndicate an idea of your feature. If interested, the syndicate will ask for additional work; and in that case, the artist should have sufficient ideas and sketches available to add to his original presentation. The comic artist living near syndicate territory may make an appointment to see the comics editor personally or may drop his work off at the syndicate office. In most cases, the submissions will be held for several weeks before a decision is made.

Since strip originals are large and oddly proportioned, mailing is made easier by first photostating the originals, reducing them to the size they will appear in the newspapers. These photostats—glossy prints for daily strips and panels and matte prints (to be handcolored) for Sunday features—are used for mailed submissions, the artist retaining the originals. In any case, whether sending by mail or showing in person, it is wise to photostat the work so as to have copies should the work be mislaid or lost. Be sure to use corrugated board backing when mailing, to put your name and address on each piece, and to enclose return postage.

Some of the largest syndicates are: Chicago Tribune–New York News Syndicate, 220 East 42nd St., New York, N.Y. 10017; King Features Syndicate, 235 East 45th St., New York, N.Y. 10017; Newspaper Enterprise Association, 7 East 43rd St., New York, N.Y. 10017; Publishers-Hall Syndicate, 30 East 42nd St., New York, N.Y. 10017; Register and Tribune Syndicate, 715 Locust St., Des Moines, Iowa 50304; and United Feature Syndicate, 220 East 42nd St., New York, N.Y. 10017.

For complete listings of all syndicates—their editors, features, artists, and titles—get the *Annual Syndicate Directory* distributed by *Editor and Publisher*, 850 Third Ave., New York, N.Y. 10022. This firm also puts out a trade weekly, *Editor and Publisher,* which gives the latest news on upcoming features and comics in general.

A syndicate contract usually offers the cartoonist 50 percent of the proceeds of sales to newspapers. Small newspapers may pay as little as 50 cents weekly for a feature—others, as high as $200 (prices are based on newspaper circulation). A few syndicates pay the comic artist a set yearly salary with possible raises when contracts are renewed.

COMIC BOOKS

COMIC BOOKS are continually being produced in great quantities. Categories include: adventure, humor, biography, detective, fantasy-mystery, fashion, teen, military action, romance, science-fiction, space, and western subjects. The majority are publishers' enterprises for newsstand sales. Others are made up and distributed by government and private agencies, and by industry. Armed forces–conceived comic books are used as training manuals; firms like General Electric and B. F. Goodrich have brought out educational books as giveaways.

There is work here for the writer, the comic artist, and the serious artist. The realism demanded in much of this area gives to the illustrator who is familiar with the comic book technique (variety of brush strokes, dry brush, stipple, crosshatch, bold blacks, silhouettes) a chance to take over. Variety of subject matter gives everyone a break. The "comic" comic books may be originals, and in many cases extensions of well-known syndicate characters such as Beetle Bailey, Sad Sack, and Dennis the Men-

ace converted to these books with new stories illustrated by men who are able to imitate these characters.

Comic books and comic strips are close cousins. Some who have not made a sale to a syndicate work for the comic books until they hit pay dirt in the newspaper field. The training is invaluable. Walt Kelly and his *Pogo* obtained their start here and went on to lush syndicate contracts. Many realistic artists have also graduated from this school and have gone on to the greener syndicate pastures. While comic books do not provide pay as fabulous as that obtained from starring newspaper panels and strips, the work can be regular, there is much of it for capable artists, and a good income is achieved on a quantity basis. Rates vary with each publisher and add up to $30 to $50 per finished page consisting of about six panels. This includes story, lettering, drawing, and inking. Assignments are given in volume: sometimes five or six pages at once, sometimes in entire books of thirty-two pages. At times, the work is cut up among specialists—at so much per page for the story, the lettering, the penciling, and the inking. The versatile man who can perform solo from plot to ink line obviously never lacks assignments.

Comic book work is mostly free lance. Study comic books; these seminars are available at newsstands for as little as twelve cents a copy. Get to know the format. Original drawings are usually made twice the size of the reproduction. Brush is used mainly, the pen occasionally. The artist who has the ability to write scripts may submit these to publishers with samples of drawings. Sample originals are photostated down, matte finish, to comic magazine page size and sometimes colored to simulate the finished printed page. Aside from the ease of handling and mailing photostats, they serve as additions to the art editors' files for reference on possible future assignments. The cartoonist trying to get work doing books that deal with known characters such as Blondie, Mutt and Jeff, Archie, etc., must imitate these in his sample pages. Publishers' names and addresses are to be found in the comic books that you buy. Most firms are concentrated in the large metropolitan areas, particularly in New York City.

A separate field is comic books for industry. Orders for these books are obtained from commercial art studios, directly from industrial firms, or occasionally from advertising agencies. These comics are used to promote a product and are not for newsstand sale. For instance, a milk company may leave a comic book on the doorstep with each milk delivery—a magazine providing entertainment for the youngsters, with a dash of advertising. A gas station may give away comic books produced by a tire company. Comic books for industry are done more meticulously than those produced for the newsstands; advertising budgets are ample. It naturally follows that art-work fees for ad comics are considerably higher than those for newsstand books.

Jack Markow

JACK MARKOW, a practicing cartoonist for many years, has had thousands of cartoons published in leading magazines here and abroad.

He studied drawing, print making, and painting at the Art Students League under Boardman Robinson and Richard Lahey, and at the Académie Moderne in Paris under Jean Marchand. He sold his first cartoon to *The New Yorker,* and since then his work has appeared in many publications, including *The Saturday Evening Post, This Week Magazine, Ladies' Home Journal, Holiday, The New York Times Magazine* and *Book Review, Argosy, True, Sports Illustrated, Redbook, McCall's, Cosmopolitan, Nation's Business,* and Canada's *Weekend Magazine.* His work has been reproduced in many cartoon collections, including Thomas Craven's *Cartoon Cavalcade* and all editions of *Best Cartoons of the Year.*

He is also the author of three books, *Drawing and Selling Cartoons, Drawing Funny Pictures,* and *Cartoonist's and Gag Writer's Handbook.*

He has done cartoon ads for such accounts as Tydol Gasoline, Post Toasties, Parker Pen, Marlin Blades, Dentyne Gum, Kelly Tires, Bacardi Rum, Angostura Bitters, and Metro-Goldwyn-Mayer.

His syndicate work includes free lance panels for King Features and McNaught. He also drew "Pepsie and Pete," a Sunday page advertising Pepsi-Cola, and "Bondie," a daily strip advertising Bond Bread.

As a painter and print maker, he has exhibited in many leading galleries and museums in this country, and he has had three one-man shows in New York City. His work is found in the permanent collections of the Metropolitan Museum, Hunter College, City College, Brooklyn Museum, University of Georgia, and others. Mr. Markow's varied experience includes several years as Cartoon Editor of *Argosy* magazine and originator of the course in magazine cartooning at the School of Visual Arts, New York, where he taught for eight years. Many of his students are now prominent in the magazine and syndicate cartooning fields. He also writes a monthly column, "Cartoonist Q's," for *Writer's Digest.*